Balentrick Ho.

Smithy

Church

Kilcrister Ho.

nugh Seafield

Seaport Ho.

spect Point

Malahide Point

Coast Guard Sta.

Carrick Br.
Carrickhill
Yellow Walls Casino
Brook Malahide Fold 21
Mill Ch. Sea Park
56 Sea Park Ho. Sea View
La Mancha 80
Auburn Cot. Church 117 100 Castle
irville Auburn Ho. Malahide Roberwalk 35
Castle St. Patricks Sea Mount
100
Brownfield Ho.

Saint Helena
112 White Park
Feltrim Black Wood
Brier Hall
Smithy Manningmore Deephurst Ho. 49
Cottage Grange Ho. St. Marnocks
Hazel Brook 19 Carrick Hill Church
Auburn Ho. Church Church
48 Ch. School
School Church Smithy
Kinsale Burrow
Emsworth Smith
Church
Shellmartin Portmarnock Ho.
Portmarnock 54 J.R. Portmarnock Br.
Cottage 50 Station 16
town 100 Merton
Lime Hill
64 St. Doolagh's
St. Doolagh Park
t. Doolagh Ho. 83 44 Wayne Locke

6 11' 6 10' 6 9' 6 8'

ABBEVILLE

The family home of
Charles J Haughey

Mary Rose Doorly

TOWN
HOUSE

Published in 1996 by
Town House and Country House
Trinity House
Charleston Road
Ranelagh
Dublin 6

British Library Cataloguing in Publication Data.
A catalogue record for this book is available from the British Library.

ISBN: 1-86059-033-0

Front cover illustration: Charles J Haughey outside the front entrance of Abbeville.
Photograph © Jacqueline O'Brien.
Back cover illustration: Angelica Kauffmann roundel.
Photograph © Jacqueline O'Brien.

Designed and typeset by Wendy Williams Design, Dublin

Printed By: Betaprint

CONTEMPORARY COLOUR PHOTOGRAPHS

of HOME and FAMILY taken by

JACQUELINE O'BRIEN

Acknowledgments

The author Mary Rose Doorly would like to thank Charles and Maureen Haughey for very kindly throwing their house open to her as well as offering invaluable assistance while writing this book. Many thanks also to the Haughey family and in particular to Seán and Eimear Haughey and to Charles Haughey's secretary, Marie Sheehan. The author is extremely grateful to Richard Austin-Cooper, Beatrice Reynolds, Father Noel Reynolds, Robert and Cherry Cusack Jobson, Anne McKendry and her son Alan, Joan Kane, Christopher Heavey, Joe Thompson and Jack Moore for shedding light on Abbeville's history. Many thanks to architects Edward McParland, Maurice Craig, Hugo Duffy, Sam Stephenson, Arthur Gibney, Austin Dunphy, and David Griffin of the Irish Architectural Archive, who helped to unlock the Abbeville puzzle, as well as art critic Ciara Ferguson who gave assistance with the art collection at Abbeville. Thanks to Bruce Arnold, Anthony Cronin, author of *Dead as Doornails* and Jonathan Williams. For expert background advice on the gardens, thanks to Paddy Bowe, author of *A history of gardening in Ireland,* Dr David Robinson, Paul Cusack of the Botanic Gardens, Dermot Gavin, Dr Andrew Sleeman and C Barry Long of *Geological Survey Ireland*. Special thanks to genealogist, Máire MacConghail who went to great lengths in researching the origins of Abbeville

CONTENTS

THE AVENUE

About seven miles north of Dublin, driving off the Malahide road past the Kinsealy fruit and vegetable farms and the church of St Doulagh, you take an inconspicuous turning to the left and come across a set of wrought iron gates and a plate glass sentry box. Behind it is a gate lodge where a uniformed garda will come out and ask your name, make a quick phone call and then wave you on. As you proceed into lush parklands with great beech and oak trees, horses grazing on green meadows trimmed with thousands of daffodils in springtime, you leave behind the city and all its clamour, and enter into a quiet sanctuary of Georgian splendour. Coming into view at last, the magnificent house of Abbeville rises out of the landscape like a stately home emerging from the past.

From here on, you slip back in time to the late eighteenth century, to an era just before the bloody rebellion of 1798 and the Act of Union, when the house first belonged to John Beresford, the tax collector of Dublin, then known unofficially as the King of Ireland. The Great Irish Famine had not happened yet, and the Irish Parliament of the time was debating the notion of self-rule, when John Beresford began to nurture the idea of giving the city of Dublin an impressive architectural stamp of its own. While the people of Ireland struggled for emancipation, the architect James Gandon was brought to Dublin to build the new Custom House and the Four Courts, and in his spare time, to work on Beresford's residence at Abbeville.

Pulling up outside the ivy-clad entrance vestibule, you are greeted by the sounds of birds calling and of water cascading from the wind-blown fountain at the centre of an oval shaped front lawn. Crows cackle in the distance and initially the house itself appears deceptively small. It is only

when you see beyond the front portion and start counting the windows that you can begin to imagine the grandeur to which Beresford and the ruling classes aspired. You stand at the front door looking up at the fanlight and wonder about the Anglo-Irish ascendancy and the country over which they presided, long before the Celtic revival or the first glimmer of Irish independence. One thing is certain; these people had taste. One more look at the majestic surroundings will confirm that much.

As the heavy door is pulled back, however, and the draught excluder rubs along the limestone floor with a deep sigh, you are faced not with the imposing figure of John Beresford or one of his butlers, but by former Taoiseach, Charles J Haughey. You are sucked right back up to the late twentieth century again, shaking hands with a man who has carved his own path through turbulent times in contemporary Irish politics. Having been Taoiseach four times, held five ministerial posts and spent thirty-five years in all as a member of the Dáil, he is now remembered perhaps more benevolently in the golden years of his retirement as Mr free-travel for the elderly, or as the man who gave writers and artists a tax-free break, or the elderly Irish statesman who had an eye for the arts and set up such institutions as Aosdána and the Irish Museum of Modern Art.

Dressed casually in a blazer, open-necked shirt and deck shoes, he lets you in with a grin which is curling into a smile at the edges. He likes to linger at the door for a moment, not shutting out the elements immediately; he readily claims that he is really more of an outdoors man. He points to the birdseed lying on the cobbles in the foreground of the house and explains how he has been feeding the birds every winter. He loves the birdsong and grumbles about the squirrels who frequently sneak in from the tall trees and gorge themselves until he himself goes out to scare them away. 'I have to use a bit of bad language at them now and again,' he admits.

He doesn't wear a watch, and measures time by the three sundials in the grounds of Abbeville. At eleven am, Abbeville time, he has just returned from his early morning ride along Portmarnock Strand on his prized sixteen-hand hunter, Gatsby. This ride in the company of his old friend and neighbour, retired builder, Standish Collen, is one of the most sacred parts of Charles Haughey's day, something he would never cancel.

Commuters in the early morning rushing into the city will look out and envy the two horsemen galloping freely along the beach, little realising that one of them is Charles Haughey, whose name, like that of Beresford before him, is written in stone as someone who changed the architectural face of Dublin by becoming the driving force behind the city's left bank area, Temple Bar.

In Irish, the name Haughey actually means horseman: 'Eachaidh', he points out proudly. Still whipping the riding crop against the palm of his hand, the man who has been called everything from the Boss to the Squire, leads you up a flight of wide stone steps under the oculi, past the niches on either side and into the majestic hallway, surrounded by oil paintings of his family. What is instantly curious about the interior of Abbeville is how its famous architect, Gandon, ingeniously built the new house around the original Jacobean villa, adding on a ballroom, dining-room and bedrooms, along with the stables and dairy outside.

Charles Haughey has lived here in the Barony of Coolock since 1969, when he bought Abbeville and added a new layer of history to this two-hundred-year-old, listed mansion. His own favourite room is the ballroom which leads on from the hall. Divided into three sections by two low-slung segmental arches, the ballroom is the most exquisitely preserved part of the house, with its Adamesque plasterwork and husk decorations on the walls which incorporate circular painted medallions. Bearing in mind that the Custom House and Four Courts were destroyed by fire at various pivotal moments in Irish history – during the War of Independence and the Civil War – the ballroom at Abbeville is said to represent the finest surviving Gandon interior in the country. According to Gandon expert, Edward McParland, it is 'the most splendid and least known example of any Irish neo-classical domestic interior in existence.'

It is in the ballroom that Charles Haughey feels at his best. It is here that, over the years, he has entertained many of his friends and supporters. His eldest and only daughter, Eimear had her wedding breakfast in this room with around forty or fifty guests. Pointing out through the bow-windows onto a westerly aspect, he shows you the Abbeville lake with its lone swan for whom he has been trying to find a partner. All around, as far as the eye can see are wooded lands of walnut, cedar, beech, oak and three-

hundred-year-old yew trees which could easily go on for another three hundred years.

Everything that has been planted round Abbeville reaches a great age, and Charles Haughey explains fondly how he has consistently replanted the woods in the thirty-odd years that he has lived here. Each time a tree falls it is used to make furniture for the house, and is replaced by at least one young sapling. A fine house like this deserves to be surrounded by fine grounds, he adds, and when you ask him a practical question as to how long he'll be available to show you the house, he narrows his eyes and deliberately misunderstands the question, joking: 'I'll be around for a good while yet.' Perhaps the famed male Chinese ginkgo tree at Abbeville, reputed to give eternal youth to the person who eats a leaf every day, will make sure of this.

Throughout the house, the new layer of the more recent Irish past is in evidence on the walls. The dining-room is dominated by a life-size oil painting of Charles Haughey's most revered hero, his father-in-law and former Taoiseach, Seán Lemass. Other rooms are hung with portraits and photographs of de Valera, Seán Ó Riada, and Samuel Beckett, the people he knew and admired, and among them his lifelong political ally and friend, Brian Lenihan. One of the rare, original Poblacht na hÉireann proclamations of 1916 hangs prominently as a centrepiece on a wall in the billiard room at Abbeville, giving the house a further sense of shifting historical irony.

'I live here because it's a beautiful house. It's a pleasure to be in it, it's ideally situated and I like to think about its history. I think it's great that all over Ireland, Irish people are back into their own, inhabiting their own country, enjoying their own country and the good things in it. That is very important, but I'm really much more interested in being in the house for what it is. It's a lovely house with very pleasant surroundings. You would want to be a soulless creature not be affected by its style and elegance.'

In 1969, when the forty-four-year-old Charles J Haughey had only just been re-appointed Minister for Finance in the new Jack Lynch cabinet, he and his wife Maureen and their four children, Eimear, Conor, Ciarán and Seán moved from Grangemore, a rambling Victorian mansion near Raheny, to their new home in Kinsealy. In fact, it was exactly one week after the general election when the removal men came in their trucks to move everything to Abbeville. Initially, the Haugheys discussed the idea of a time and motion study to find the most expedient method for moving house. In the end, however, it became more like a study in the theory of chaos, and Maureen recalls how at the last minute, in post-election euphoria, Charles decided to throw a party for their friends and supporters at the old house in Raheny. In addition to that, he made the magnanimous gesture of buying a barrel of beer for the removal men, so that her recollection of the move is one of pandemonium, with men drinking beer on the lawns of Abbeville in early summer and the furniture coming to a standstill outside the house.

Perhaps the excitement of moving into such a fine Gandon mansion as Abbeville merited this unique approach. What the Haugheys found before them was a house of exceptional architectural quality, steeped in history even before the future Taoiseach set foot inside its vestibule. Having bought Abbeville from a German industrialist who had scarcely lived there at all in the six years of his ownership, and had allowed the house and gardens to fall under a spell of neglect, the Haugheys moved in and turned it once more into a family home. Unlike many of Ireland's big houses which are often inhabited with frugal, loving care by aging descendants of the original owners, Charles Haughey was in a position to maintain Abbeville in the splendid state to which it had already been

restored. It became a place where the future head of government entertained distinguished guests such as François Mitterand, Bob Hawke and Brian Mulroney, as well as becoming a thriving Irish household.

During his predecessor's reign as Taoiseach, Jack Lynch had initiated plans for the state to commission a Taoiseach's residence which would reflect the dignity of the office, something on the scale of Number Ten, Downing Street, where visiting heads of state could also be entertained. When Charles Haughey succeeded Jack Lynch ten years later in 1979, the idea of a state Taoiseach's house was abandoned for all the obvious reasons. Charles Haughey was the owner of one of the most magnificent Irish mansions, which with its ballroom and dining-room, extensive kitchen and wine cellar, was an ideal location for protocol receptions in surroundings that exuded almost three hundred years of Irish history.

Nobody knows exactly how old the original Abbeville is, only that the land was once thought to have belonged to the Cistercian monks. On Roque's map dating back to 1760, which hangs on the wall at Abbeville, the name of the house is marked as Abby Well. This was changed by the Right Honorable John Beresford who is believed to have bought the house from the Kildare landowner, Edward Beaver in 1760 and renamed it Abbeville in honour of his wife who came from a town of that name in northern France. There is evidence to suggest that the original house dates back to Jacobean times, and that it had already come in for at least two separate alterations before John Beresford commissioned James Gandon to upgrade it to its present condition.

James Gandon is now seen as Ireland's greatest architect. It may be said that in a country which is perhaps least known for its architecture and which, due to its historical background, has possessed very little other than the thatched cottage in terms of indigenous building design, Gandon's elegant neo-classical masterpieces of the Custom House, Four Courts, the Rotunda Assembly Rooms and such houses as Abbeville can be adopted as the finest examples of Ireland's architectural heritage.

James Gandon came from London, arriving in Ireland at a time when he was no more than a promising architect with a greater reputation for his drinking and gambling habits than for his work. In order to leave his debts behind, he accepted a commission from Dublin's Revenue

Commissioner, John Beresford who, with other noblemen of Dublin at the time, had plans to change the skyline of the city. Along with the notion of a self-governing state which would have permission to trade independently with the rest of the world, Dublin's élite businesspeople wanted to erect key buildings which would raise the profile of the city. Beresford's first mission was to build a new Custom House nearly a mile downstream from the existing centre of commerce which was on the south side of the Liffey. This move would enable Beresford to acquire more and more influence over the city, as well as improving his wealth and that of his family and friends. By erecting the ambitious new Custom House on the north bank, he and his colleagues could take control and reshape the north of the city where most of the noblemen of Dublin resided at the time.

There was much opposition to the idea of a new Custom House, coming mostly from traders and businessmen around Dublin at the time. It was into this rancorous atmosphere that James Gandon arrived in 1781, the same day that Henry Grattan declared Ireland to be a new nation. Knowing that there was so much opposition to his new plans, Beresford virtually incarcerated the forty-year-old architect in his Dominic Street mansion while he worked on the Custom House commission, only allowing him out during the first three months in order to take measurements at Abbeville.

At the time, Abbeville was a gentleman's villa. With the general restructuring of Dublin to the north of the city, Lord Beresford asked Gandon to remodel his country estate at Kinsealy into a substantial mansion in his spare time, an incidental job for which it is believed Gandon was never actually paid. In his memoirs, Gandon recalls his loneliness and isolation during his first months in Ireland. Charles Haughey believes that Gandon must have found the original 'Abby Well' house very charming. He liked the existing Jacobean and Elizabethan structures so much that, instead of demolishing and designing a completely new building, he decided to incorporate the old house into a lavish new structure, and as with all his buildings, he worked with superb craftsmen, whose robust and tasteful work remains a hallmark of the house.

Abbeville also represents a departure from type in terms of Gandon's architectural portfolio in that it remained one of the few domestic houses he ever worked on. Apart from houses such as nearby Emsworth, and Carrickglass, most of his life's work was devoted to public buildings, culminating with the King's Inns. Contemporary architects who visit Abbeville remark on the many extraordinary features, such as the addition of Greek baseless Doric columns at the entrance of the house, which seem at first to be incongruous and out of step with Gandon's strong neo-classical or Roman leanings. Gandon experts are puzzled by such bold moves from an architect who was fundamentally anti-Greek.

John Beresford, having rebuilt one of Ireland's finest houses, eventually moved on, retiring to his Derry estate and leaving Abbeville to his son John Claudius, the banker, who went bankrupt some years later and lost the house through a forced sale to Austin Cooper. Cooper was a famous antiquarian who bought the house in 1814 along with 53 acres of land. He was the deputy constable of Dublin Castle, a very wealthy man who managed the property of many noblemen and proceeded to enlarge the Abbeville estate considerably. Cooper kept meticulous diaries, which give us a fascinating insight into the house and the conditions which prevailed in Ireland at that time. Charles Haughey, who owns one of the rare copies of Cooper's published diary of 1759-1830, said it felt like having one of his teeth pulled to lend this precious document which he had sought to obtain for years.

Cooper died in tragic circumstances, in a carriage accident while on his way from Kinsealy (then called Kinsaley). After his death, he left behind a huge personal collection of rare books. He had built a fine vault in Kinsealy several years earlier, and his remains are interred there.

Abbeville was subsequently sold in 1830 to James William Cusack, surgeon in ordinary to the Crown, who was an even wealthier individual. His town house was what has since become the Kildare Street Club, and apart from large properties in Meath and Westmeath, he also owned many houses surrounding Abbeville. His estate ran from the old Portmarnock Church to Cloughran, taking in all of the villages in the north of Dublin; a vast domain of two thousand acres in all. Abbeville remained in Cusack hands for over a hundred years until it came into the possession of Ralph

Cusack, who celebrated the end of the ascendancy era by turning to travel and long holidays abroad, and who eventually sold the estate in 1948 to Percy Reynolds.

One of the most famous residents at Abbeville during the Cusack tenure was the celebrated nun who became known in history as the Nun of Kenmare. She became an Anglican nun and converted soon afterwards to Catholicism. She founded a convent in Kenmare where she worked with the poor and wrote many of her fifty controversial books. It was remarkable at the time for a Poor Clare nun to write books at all, but to write such revolutionary works, many of them railing against landlords and bishops, was extraordinary. She was the niece of Sir James William Cusack, and according to her biographer, her parents, herself and her brother came to live at the house for a short period when Cusack's wife died.

Percy Reynolds, the famous horse breeder and chairman of CIE, bought Abbeville from the Cusacks primarily to set up a stud farm. With its fine stables and its proximity to Dublin city, Abbeville seemed ideal for such an option. Percy and Beatrice Reynolds lived at Abbeville with their large family until the stud farm enterprise failed, when the estate was sold on once more in 1963, this time to a German industrialist called Franz Zielkowski. The Gandon rooms had been restored at great cost by the Reynolds during their tenure, under the direction of architect Michael Scott.

Zielkowski, from whom Charles Haughey finally bought the house in 1969, did not appear to do much more than act as a caretaker for the six years or so of his ownership. Haughey first heard about the house when he was visiting his old friend and fellow horseman, Standish Collen, who was aware that Zielkowski might be open to offers. Having sold Grangemore in Raheny, Charles Haughey was then in a position to buy Abbeville for £120,000. Zielkowski had purchased the house from Percy Reynolds for a mere £25,000 only six years earlier. This appears to have been a knockdown price, since Percy Reynolds had bought the house for £15,000 and had spent a vast amount on renovating and restoring the Gandon rooms to their original elegance. The price which Charles Haughey paid seems to be more in line with the real value of the house

at the time, even though some years later he sold off a field for more than the original price of the entire estate, effectively acquiring Abbeville for nothing.

There is no record of what Beresford paid for Abbeville, but it is known that Austin Cooper purchased the house from Beresford's bankrupt son for a sum of £5850, a fortune in those days. Cooper could see, however, that by buying up some additional land, the grounds around Abbeville could be extended into a substantial estate, thereby adding great value to the house. Today, though the house once had over 2000 acres of land, during the Cusack tenure, much of this has been sold off again. When Percy Reynolds sold Abbeville in 1963, the estate included 120 acres. Franz Zielkowski bought land during his ownership, so that when Charles Haughey bought Abbeville it comprised some 270 acres.

When Abbeville and other such estates were established, the custom was to design the majestic parklands around the house as well. The boundary of the estate was normally marked out by planting a belt of trees, nearly always beech trees which grew to a great height and served the purpose of hiding the utilitarian farms of the hinterland beyond. These trees have begun to fall now, since they have grown to full maturity. Charles Haughey is persistent in his efforts to maintain the property and much of the cost of maintenance goes into tree planting, keeping the wide and various stock of broadleaf trees along the avenue and around the perimeter of the estate. Since they moved into Abbeville in 1969, Haughey has employed specialist, John Joe Costin, to advise on all aspects of tree planting.

'These trees were planted around the time the house was built, so that they are coming to the end of their lifetime now. Every few years a few more fall. So to keep up the overall surroundings, we continue to replant. In fact, our major contribution towards Abbeville is in planting trees. I love trees,' says Charles Haughey. 'To plant trees is the most natural thing in the world. It is a very positive thing to do and personally satisfying. Trees, particularly broadleaves, are an essential ingredient of the ambience at Abbeville and if possible we add additional features and groves here and there from time to time.'

With such exquisite parklands, Abbeville was always an idyllic place for a

large family. Like the Reynolds before them, the Haughey children recall having a preference for staying at home rather than going into town. TD Seán Haughey remembers tree houses, boating on the lake, and searching for an underground tunnel which was reputed to exist, though it was never found. Abbeville was also a place where the city virtually came to the country when the house was filled with visiting guests at an official Fianna Fáil celebration for Charles Haughey's election as leader of the Fianna Fáil party in 1979. Seán recalls counting over four hundred guests that night alone. There were many such gatherings at Abbeville at the peak of Charles Haughey's career in Dáil Éireann. On one occasion (11 November 1988, to be precise) a cabinet meeting was held at Abbeville because Haughey was suffering from asthma. His son Seán recalls how the then Taoiseach was forced to attend the meeting held around the great circular mahogany table in the dining-room wearing his dressing gown.

The house has also witnessed four weddings – those of Eimear, Conor, Ciarán and Seán – with the addition of a marquee on the lawn in the case of the boys. Now the house is a little quieter, since the children have grown up and moved out. With the exception of Eimear, who lives on a stud farm in Kildare with her husband, John Mulhern, the rest of the family have built new houses on the Abbeville estate, leaving Charles and Maureen as the only remaining occupants in the house, apart from the staff.

The only other resident of substance at Abbeville is Charles and Maureen's cherished guardian of the estate, Nipper. Though Maureen has bred and still owns Irish wolfhounds, this master of security is a fiery Jack Russel who is renowned for his appetite for Gardaí and journalists. Charles Haughey was quick to point out Nipper's personal chair in his study. Seán Haughey speaks about the love-hate relationship between his father and the dog, a power struggle which has developed even more since the former Taoiseach left office in 1992, and since they now have the entire house almost to themselves. This was confirmed one day when Nipper, the custodian of Abbeville, growled at me in the vestibule, and Charles Haughey instantly growled back.

It could well be said that to this day Charles Haughey continues to live in Abbeville in a manner that in some ways resembles the tenure of its first owner, John Beresford. The fact that his three sons have chosen to settle on the estate in a dynastic fashion could be more in keeping with the eighteenth or nineteenth century than the present day. This is admired by many people in the firm belief that a house of such beauty and grandeur deserves an eminent owner or occupier who carries on the traditions of bygone centuries. The reality is, however, more related to economics; land prices around Malahide are astronomical for young people wishing to build a home. It could also be said that Charles Haughey's terms of office in the service of the state, as Taoiseach and leader of the Fianna Fáil party with its republican credentials, have allowed him to preserve tradition with a style that would be difficult for descendants of the Anglo-Irish gentry to attempt to emulate. By plucking the best and most valuable aspects of the 'big house' and fitting them into a present-day setting, Charles Haughey has found a way of moulding the grandeur of the eighteenth century into the ordinary family lifestyle of the Irish republic of the late twentieth century.

Architect and admirer of Gandon's work, Arthur Gibney describes Haughey's presence in Abbeville as a 'seigniorial tenure.' Having his family around him is considered by Gibney and many others to be a mark of Haughey's great vision in which he has managed to incorporate the past into the present. 'He is capable of picking up patterns from the past which are fascinating, and I am delighted that he is able to indulge in them. He is a curious mixture of the past and the future,' says Arthur Gibney.

When Dr Conor Cruise O'Brien once described Haughey as 'an aristocrat with a common touch,' he did not realise what a compliment this was. The interior of Abbeville proves this point beyond any doubt. Soon after he moved in, Haughey asked the architect Sam Stephenson to make a crucial alteration, by building one of the most enduring symbols of rural Ireland into this fine eighteenth-century house. It was the kind of feature that neither Gandon or Beresford would ever have dreamed of – an Irish pub. With a certain sense of Republican irony, it seems that the focal point of this elegant mansion has shifted somewhat from the ballroom to a typically rural Irish bar which Haughey had installed just beyond the Malton room in the south wing. That which, over the last two centuries, has become the common living-room of the people, one of Ireland's most democratic institutions, has now made its way into the heart of the lifestyle of a Gandon mansion

As an architect and friend, Arthur Gibney retains some 'abiding memories of a more informal hospitality, rather than the grand hospitality of the ballroom' at Abbeville. He describes this country bar as the real heart of the Haughey home where the family and their friends are most likely to gather. Meetings which are held in the study will often end up shifting there. The bar was bought when a finance institution in Belfast was knocked down. The counter is described by Sam Stephenson as Edwardian, with mini Gothic columns which were all rotary cut and very decorative. The panel section at the back of the bar came from the same place, with detail of the same period.

The bar also contains an old, gold coloured, heavily decorated cash register. Along the back of the bar, old bottles are lined up, as well as packets of Woodbine, Craven A and some Russian brands of cigarettes. Sam Stephenson feels they started a renaissance in Anaglypta wallpaper when they used it to give it the feel of an old pub with the walls discoloured by smoke. Sketches, photographs, mirrors and paintings line the walls, along with a famous replica of Charles Haughey as Mona Lisa which once appeared on the cover of the now defunct *Hibernia* weekly magazine while he was Minister for Finance. A bottle filled with coins stands on the bar and a number of flute champagne glasses stand upturned on a towel. In the background, the icemaker hums and shudders. One of the central features of the Haughey bar is a large painting

commissioned by Haughey in 1985 from the artist Muriel Brandt. It depicts a busy point-to-point meeting in County Meath and is populated by the entire Haughey family. When the artist died five years later, she had rubbed out most of the painting in order to start afresh. The painting had to be handed on to RHA president, Carey Clarke, who subsequently sent it for additional work to Tom Ryan. By the time the painting was finished, the whole Haughey family had made their way back into the race meeting; Maureen Haughey is shown leading a horse across the field while Charles Haughey stands in the foreground with Standish Collen behind him. A 'Vote Haughey' banner flies above the crowd while Haughey's adviser of the time, Padraig O'hUigín, serves tea behind a stall.

Along the other walls in the bar are countless more objects which Charles Haughey has collected over the years, such as an encased hurley stick to remind the patrons of this establishment of Haughey's past battles on the field of play.

The heavy mahogany double doors of the bar have EC engraved onto the acid-etched crystal glass insets. Sam Stephenson was quick to remark that the doors did not come from the European Commission but from another country pub. 'They were throwing things like this out all over the country at the time to redecorate bars. Architectural salvage did not exist then,' says Sam Stephenson, who also designed the Horseshoe Bar in the Shelbourne Hotel, the most successful bar ever owned by the Forte chain.

'Whenever there is an informal party in the house,' confides Maureen Haughey, 'people are inclined to head for the pub atmosphere.' The bar was also cleverly designed in such a way as to provide the maximum noise separation from the rest of the house. 'I seldom knew what was going on with the children,' says Charles Haughey. 'Our bedroom is over on the other side of the house and they could be up to any sort of mischief and we never heard a thing. It probably suited them as well as it suited us.'

Seán Haughey recalls being in a position to make the best use of this wonderful separation and speaks of eluding the adults. 'When we were younger, our cousins would come out and we'd spend the whole night at the old boathouse at the end of the lake, going mad without any parental control. We'd never go to sleep at all. On other occasions we'd sleep out in tents and get up to all kinds of divilment, switching the horses around

to different stables. On one occasion we hid our mother's car in one of the stables.'

When the children were older, the fun would more readily gravitate towards the bar, with the odd couple of beers. 'When there was a party, it was often an open house,' adds Seán Haughey, who remembers occasions when people simply made their way in off the street. 'Everybody assumed they were with somebody else.'

Maureen Haughey talks about her husband's hospitality and his pleasure in having visitors in the house. Seán points to a kind of traditional loyalty which Charles and Maureen Haughey show to their old friends. 'The situation is that usually when someone comes to call, Charlie's there chatting away and won't let them go.'

One of the central characters associated with Charles Haughey's political career was the government secretary, P J Mara. On one occasion, it is told, when P J Mara was courteously reminding his boss that he had a meeting to attend at the Shelbourne Hotel, he was given a piece of very pertinent advice about the nature of bar-room ethics. Having consumed a bottle of Haughey's best white wine and having already started another, the general feeling was that it would be sinful to abandon a bottle of such quality. Charles Haughey, who then rushed off to the meeting in town, is accredited with the words of wisdom that 'some things in life have to be rushed, but good wine is not one of them. Stay where you are, Mara.'

The wine itself is kept in a red brick cellar probably designed by Gandon, and situated in the basement under the entrance vestibule. Charles Haughey is an expert on wine and during a tour of the cellar he points out some of the more precious items in his collection. 'Here is a Chateau Margot 1957, the year when Fianna Fáil came into office and I was elected to the Dáil. There's a Mouton Rothschild '67 and a Chateau Laffite 1920. I used to collect a lot. On my birthday, somebody gave me that red from the year of my birth, which is a very fashionable thing these days. That's a Chateau Yquem, one of the real gems. There are five great wines in the world, four of them are reds and one of them is white and this is the white,' says Charles Haughey who keeps the cellar firmly locked.

Sam Stephenson recalls dinner parties that Charles Haughey held for his friends over the years, among them well-known people such as the celebrated actor Mícheál Mac Liamóir who, like Hilton Edwards, came from a London cockney background and reinvented himself in Dublin in the fifties. Mícheál Mac Liamóir, whose original name was Michael Wilmore, is remembered for great nights when he kept the dinner table at Abbeville entertained into the late hours with his extraordinary wit and story telling. Hilton Edwards who was known to be far more quiet and reserved, surprised everyone one memorable night, however, when he took over with his dormant talent as raconteur.

Mícheál Mac Liamóir, who was performing at the Gate Theatre in Dublin in the part of a chieftain, told the assembled guests at one point of the chieftain's chair which he had had made specially for the play. On hearing this, Charles Haughey became very interested and later acquired this chieftain's chair which is now in his holiday island of Inismhicileáin, where Sam Stephenson remarks jokingly, 'CJ is the undisputed chieftain.' Copies of this chair and a companion table were also made for Abbeville.

Over the years, Saturday mornings at Abbeville became an established rendezvous for his friends, many of them architects like Austin Dunphy and Arthur Gibney, who would come to discuss current projects related to the house and lands. Austin Dunphy holds the title of honorary curator of Abbeville, and ensures that all parts of the house have complete conformity, everything being kept in the Georgian style of Gandon's work. The ballroom, for instance, is designed by Gandon in such a complete and rounded way that it is difficult to add even a painting or a small etching without disturbing the overall shape of the room, a fact which occasionally causes some friendly disputation.

'CJ and I are always arguing about it,' says Austin Dunphy, who feels that there is so much decoration built into the room in the form of niches, plasterwork and Angelica Kauffmann roundels that it is virtually impossible to add anything. 'The problem with a room like this is that it's very hard to imprint your own personality on it. People don't like to be told what to do. During the Adamesque and Wyatt period, every inch of your wall and ceiling was decorated, leaving no space to hang a portrait of your mother or your wife on the wall. CJ used to hang pictures in the

ballroom and I'd go and take them out. The only picture that he's allowed to put up there, and we often joke about it, is a watercolour of what you can actually see out the window, a view of the terrace.'

Austin Dunphy also felt that the niches in the ballroom needed to be filled, and designed special pedestals, one of which holds a bronze bust of Charles Haughey. Arthur Gibney has also added various features to the house over the years, but most of his work for Haughey, however, consists of designing his Christmas card each year, the last of which was a dramatic action shot of Flashing Steel, the prized Haughey racehorse which has won many trophies in its steeplechase career. A collection of a dozen or more of Gibney's Christmas cards are displayed over the doorway in Charles Haughey's study.

At the end of the Saturday morning discussion in the study, the conference shifts to the bar where Maureen Haughey brings in sausages and French bread, the *paysanne* lunch adding a homely touch. Arthur Gibney feels that Charles Haughey 'lives in the style and manner suited to the house. The place is full of horses, dogs, full of local people and his friends. What comes across is that Haughey lives up to the standards of the eighteenth-century landowner.' The surroundings of Abbeville contain many other aspects of Haughey's passions, including pheasant and duck. At various times of the year, horse trials are held at Abbeville and red deer are bred on the land.

Along with many of their friends and supporters, Seán Haughey admires the way in which his father has been able to take over from the Anglo-Irish with such ease and flair.

'I have a sense of satisfaction that many of the big houses which were owned by the Anglo-Irish aristocracy over the last two hundred years are now lived in. Though I wouldn't be as pushy as to say they all fell into their rightful hands, Abbeville is owned by a genuine native Irish republican who can respect the house and have regard to its heritage and its place in the cultural scheme of things. We won our independence in 1922 and it was only a matter of time before this would happen. Of course the Anglo-Irish heritage is important as well because it's part of our history and I'm certainly not of the opinion that we should tear down all these monuments because they were British. In fact we should treasure

them. Probably some of the Anglo-Irish aristocracy, if they were alive today would be horrified to see Mr Haughey, Republican extraordinaire, living in this big house. But that's the way things change.'

BERESFORD'S

COUNTRY VILLA

As you walk around the grounds of Abbeville and look back at this majestic edifice surrounded by trees and lush gardens, you are struck on the one hand by an impression of overwhelming beauty, while on the other, you feel the inevitable tug of history pointing accusingly at its origins. As you survey the walled-in gardens and their exotic orchards with the hum of beehives in your ear, or crunch back across the gravel path in order to linger once more in Abbeville's magnificent rooms, you surrender to an enduring sense of aesthetic triumph which never quite escapes the reality of power and corruption under which this fine mansion came into existence. On the surface, life seems to have been a masterpiece. Underneath, it was a murky era of cosy business arrangements, nepotism and land-grabbing.

When the Right Honorable John Beresford asked James Gandon to remodel Abbeville in the 1780s, he presided over a country which was moving towards the rebellion of 1798, but which was also undergoing another more subtle power struggle, one which would award him supremacy and give him the nickname 'King of Ireland.' At the time, the ascendancy in Dublin were clamouring for self-government, and seen from Beresford's point of view, this did not include any aspiration towards the emancipation of the Catholic peasants whom he despised. Instead, Beresford and his companions in business saw the notion of self-rule as an opportunity to seize control of Dublin and the rest of the country for themselves.

As Commissioner of the Revenue, John Beresford was able to use his position to acquire enormous wealth and power over Dublin, changing the face of the city and moving the centre of commerce to suit himself, his

family and friends. Many of the central features of Dublin to this day reflect his bold and controversial reshaping of the city to his own ends. The most prominent of these are the Custom House and O'Connell Bridge (then called Carlisle Bridge) which gave access to the north of the city and stopped shipping from going beyond that point to the old centre of commerce around the Royal Exchange and Capel Street Bridge. Despite huge opposition, Beresford was able to achieve this and pass over a great wealth to his son John Claudius on his death in 1805.

An anonymous piece of doggerel which dates back to shortly after John Beresford's death parodies the Beresford empire and illustrates the depth of public opinion and resentment towards them at the time.

'I believe in John Beresford, the Father Almighty of the Revenue, Creator of the North Wall, the Ottiwell Jobb and the Coal Tax, and his true Son John Claudius, who was conceived in the spirit of the Chancellor, born of the Virgin Custom-house, suffered under Earl Fitzwilliam, was stigmatized, spurned and dismissed. The third week he rose again, ascendeth into the Cabinet and sitteth on the right hand of his Father, from whence he shall come to Judge by a Court Martial both the Quick and the Dead, those who are to be Hanged and those whose Fortunes are to be confiscated. I believe in the Holy Earl of Clare, in the Holy Orange Lodges, in the Communion of Commissioners, in the forgiveness of Sins by acts of Indemnity, in the Resurrection of the Protestant Ascendancy and Jobbing everlasting. Amen.'

Beresford himself said that no Lord Lieutenant could exist without him. His power was almost absolute by the late eighteenth century when the Protestant ascendancy were calling for their own independent government, and it seemed as though Beresford and his entourage were set to spread their control as they wished across the country. This was done in an atmosphere of corruption, secret land deals, bullying and a general arrogance to ensure that he got what he wanted, setting up a vast and lucrative empire for himself and his ubiquitous relatives.

Another celebrated incident which describes the virtual omnipotence of the ruling classes in Dublin at the time, concerns the famous trial of a Dublin landlord and his son who were accused of murdering their coachman and valet on separate occasions but who were ultimately found

not guilty. The common perception held otherwise, however, and the father and son were nicknamed Killkelly and Killcoachy by the ordinary people of Dublin, demonstrating the quality of justice which applied to the gentry in Ireland in the eighteenth and nineteenth century.

Beresford is described by architectural historian Hugo Duffy, currently writing a biography of James Gandon, as a domineering and ruthless figure who pounded home his ideas in parliament by relentlessly repeating himself. Folk memory which survives in the Kinsealy area several generations later still recalls him as a tyrant, a man who would run over children if they got in the way of his carriage. Hugo Duffy is not aware of any such incident, though he agrees that Beresford was a formidable character who has been described more as a tyrant than a visionary.

'Beresford had power and liked to exercise it. When he became Commissioner of the Revenue he turned on a number of his acquaintances, stopping their perks,' says Hugo Duffy. 'He wanted things to be run properly. On an engraving of Beresford in the National Gallery in Dublin he looks like a very pleasant sort of man, much more pleasant-looking than people like Lord Carlow, later Lord Portarlington. But in fact Beresford was the toughest of the whole lot. He was very conscious of his position and wouldn't allow anyone to trick with it. He had his own idea of what should be done with the city, as indeed did all the lords and upper classes of that time who seemed to regard themselves as little gods who could do no wrong.'

In the late eighteenth century, in view of their power and money, the Anglo-Irish nobility seized the opportunity to put their stamp on the city, fortuitously adopting the completely unknown James Gandon as their architect. Together with Viscount Carlow who later commissioned him to build Emo House in County Laois and Frederick Trench who also commissioned him to build a villa in County Laois, John Beresford was determined to demonstrate power with lasting architectural symbols. With Beresford at the helm, the élite business class felt it was time to change the face of Dublin. Beresford was persuaded by John Dawson, Viscount Carlow, to choose the virtually unknown James Gandon to build a Custom House to equal any building in Britain. Gandon was to go on to become one of Europe's greatest architects and executed the

transformation of Dublin into the greatest splendour in the eighteenth century. In his lifetime Gandon shaped much of Dublin's skyline and was responsible for opening up the north quays with his Custom House, the Rotunda Assembly Rooms, and the building for which Gandon is most renowned, the Four Courts with its spectacular drum and dome.

At the time Gandon's career was in relative obscurity and he was unhappy at the thought of leaving his London home and his life of leisure to take on a job that was shrouded in mystery, in a country he knew little about. He really had little choice in the matter, since he was in serious debt at the time. He had been considering an offer of work in St Petersburg at the invitation of Catherine the Great, but turned it down in favour of a commission in Ireland, a country a little closer to his own.

'Beresford caught Gandon on the hop,' says his biographer Hugo Duffy. 'Gandon had almost reduced himself to penury when Beresford offered him this job. He had no choice but to take it, to come over to Ireland and do what Beresford told him. Beresford was extremely nice to Gandon, who wasn't, as far as I can make out, a very comfortable character to be dealing with. When he arrived in Ireland he found himself cut off from the people he liked to associate with in London, the architects and artists he would hang around and drink with in Covent Garden while neglecting his work.'

Beresford took Gandon in hand and appears to have frightened the young architect into action. Having been rescued from a downhill career in London, however, Gandon found that he took pleasure in the work at hand and discovered that he could express his genius in a new environment. Once he got into the habit of working, he began to excel himself, producing in the Four Courts one of the most unique and individual designs in Europe.

Beresford's ultimate power and influence over the city can be measured most accurately in the development of the Four Courts, a building which was vigorously opposed by the equally powerful Teller of the Exchequer, William Burton-Conyngham from Slane who was initially friendly with Gandon. Like Beresford who employed a technique of undermining his opponents, William Burton-Conyngham took Gandon into his confidence, inviting him to his estate, only to pick his brains and find out

more about his plans. Gandon knew the delicate path on which he walked, working for Beresford while not wishing to antagonise Beresford's enemies.

William Burton-Coyningham spent the last three years of his life making every effort to have the project on the Four Courts halted. There was no stopping Beresford, however, who had carefully placed his numerous uncles, aunts and cousins in different positions in government so that he knew exactly what was going on everywhere. Beresford's relations were faithful to him rather than to the people who employed them and with the use of bribery, he was able to see his wishes come to fruition.

Beresford's brother-in-law, Lord Mountjoy, owned a great deal of land behind the site of the proposed Custom House on the river Liffey, and when the axis of Dublin was shifted to the north it allowed him to develop Gardiner Street and Mountjoy Square. There were enormous building developments going on all over the north side of the city at the time, and when the aristocracy started to move into these areas, it enabled the Beresfords to amass vast amounts of money, something that was simultaneously admired and resented. Beresford's abuse of his position as Chief Revenue Commissioner was certainly not the only aspect to which people objected, and though the Custom House was generally seen as a spectacular achievement, the dissenting voices did not go away when the momentous project was eventually completed. One newspaper correspondent remarked, 'the Custom House is a noble edifice in which there is no fault to be found except that Beresford is sumptuously lodged within.' The Custom House had subsequently been given the nickname 'Beresford's Ballroom.'

When the Custom House was ransacked by the Dublin Brigade of the IRA in 1921 as one of the main symbols of British rule in Ireland, the fire burned for five days, destroying the interior of the whole building except for the North Hall. There is no record of Beresford's apartments but, according to the Dublin Evening Post of 1789, they contained fifty mahogany doors at six guineas each. When completed these apartments were said to 'vie with oriental magnificence – like the palaces of Kings and Princes.'

Beresford lived mainly in his big town house in Dominick Street not far

from his brother Lord Tyrone in Malborough Street, which now houses the Department of Education. He more or less built the Custom House as his own palace and occupied the entire front of the northern wing, top and bottom, known as the Beresford suite. This was the vantage point from which he could conduct his business and from where he could survey the new suburbs to the north like a true king.

Across the strand from Beresford's private apartments, the setting was completed by the erection of an elegant terrace at Beresford Place. It could be seen as a measure of Beresford's enduring determination that his name still remains on the plaque, in spite of calls to change the name to Connolly Place after the great labour leader of the 1916 rising. From his palatial surroundings in the Custom House, Beresford could look across at his brother-in-law's expanding estate on Mountjoy Square. With the erection of Carlisle Bridge and the widening of Sackville Street (now O'Connell Street), as well as the building of the Rotunda Assembly Rooms which were also designed by Gandon, Dublin saw a huge upsurge in development to the north of the Liffey and became known around that time as the fifth largest city in Europe.

While the privileged protestant nobility lived in great comfort, the Catholics were still living in subhuman conditions of rampant disease and poverty, and struggled to achieve basic rights. In Dublin, they lived in squalid tenements with families of up to sixteen occupying one room. With no voice in the affairs of the country, secret societies sprang up all over the city, plotting to overthrow the Protestant nobility who had been greatly alarmed for some time about the dangers of a Catholic backlash. Knowing that a rebellion would seriously threaten his own position and wealth, Beresford was in the forefront of those who challenged any move towards Catholic emancipation and remained adamant that the rebels should be kept down.

When the 1798 rebellion exploded under the leadership of Theobald Wolfe Tone, the Protestant overlords were quick to consolidate their position in order to put an end to a threat under which they would have most to lose. Gandon, who was closely associated with Beresford, felt that his life was in danger and fled to London. The rebellion was quickly quashed, however, with savage and brutal reprisals. The bodies of

Catholic rebels hung over the Liffey from Carlisle Bridge which had been designed and built by Gandon between 1792-5, and was turned into a gallows for the occasion. Beresford's son, John Claudius the banker, who later became the owner of Abbeville, made a perverted science of the torture of the insurgents.

With the Act of Union in 1800, which abolished the Irish Parliament, many of the Anglo-Irish aristocracy decided to return to England, taking their wealth and culture with them. This had a catastrophic effect on the economy of Ireland and brought the expansion of Dublin to an end. The economic decline, along with the famine later on, halted the growth of towns until the Victorian and Edwardian eras, and Dublin gradually slid into provincial obscurity.

In the heyday of Dublin's brief but significant architectural revival of the late eighteenth century, however, Beresford, through his architect, James Gandon, had managed to leave an indelible mark on the city. In December 1760, Beresford bought a rather small dwelling house with a garden, outhouses and 53 acres of land at Feiltrim, in the Barony of Coolock, to the north of the city centre. A granite milestone at Kinsealy still points to Dublin as being seven miles away. A perfect distance from the city's new centre of commerce, he bought what was then called Abby Well from a Kildare landowner called Edward Beaver, it is believed. He then renamed it Abbeville in honour of his first wife.

On 12 November 1760 John Beresford married his first wife Anne Constantin de Ligondes, who was to die ten years later shortly after the death of her fourth child. She was daughter of General Comte de Ligondes of the House of Ligondes in the town of Abbeville in Auvergne in France. Beresford first met Mlle de Ligondes when she was on a visit to Newbridge House, residence of Archbishop Cobbe whose brother had met Mlle de Ligondes when visiting France. At the time she was preparing to enter a convent.

'From what I can see Beresford was a complete rascal,' says Hugo Duffy. 'His first wife was actually going to become a nun in France when her aunt, Lady Moira, persuaded her to come to Dublin and marry Beresford. It seems as though he went out there and half kidnapped her under the noses of the reverend mothers of the convent. Beresford was only too

delighted to pervert any Catholic since he had quite a hatred of the Catholic Church. So he got his way and married her and she had four children, two of which appear to have been the greatest blackguards in Europe.' These were George de la Poer, Bishop of Kilmore and Ardagh (1765-1841) and John Claudius Beresford (1766-1846).

In 1777 Beresford married Barbara Montgomery, daughter of Sir William Montgomery, a Scottish baronet who lived in Greenwood, a neighbouring estate close to Abbeville. She gave birth to three children. The third child, who died at the age of two, is buried in Kinsealy graveyard. The marriage had interesting links, as one of her sisters was the wife of Lord Townsend, Viceroy of Ireland and another sister was married to the Right Honorable Luke Gardiner, Lord Mountjoy, who was killed in the Battle of New Ross in 1798. The three Montgomery sisters, notable beauties of their day, were painted by Sir Joshua Reynolds in the well-known painting 'The Three Graces' which hangs in the National Gallery in London. This painting was then copied by Angelica Kauffmann for roundel murals, one of the central features on the walls of the ballroom at Abbeville.

Barbara Montgomery, Beresford's second wife, was an extrovert and seems to have got on very well with him, though she appears to have been somewhat unconventional. In a letter written by Lady Fitzgerald she was described as the 'poor mad Mrs Beresford who came down here today with some friends.' She was looked upon by others as being a woman who didn't conform to the habits and manners of the time. Being Beresford's wife, she was in a position to do as she pleased. Montgomery Street was named after the second Mrs Beresford which, ironically went on to become the famous 'Monto' red light district of Dublin before it was closed down in the 1950s by the efforts of the Legion of Mary in a radical atmosphere of post-independence Catholic renewal and purity.

John Beresford retired from office in 1802 and went to live in his Derry residence, Walworth, where he died in 1805, and Abbeville was inherited by his son John Claudius, the banker. Ten years later on 14 December 1814, John Claudius was forced to sell Abbeville due to bankruptcy. He owed £5000 to Alex Schaw and a court order foreclosed the sale to cover the debt. It was at this point that the antiquarian Austin Cooper bought Abbeville through his agent, Richard Sayers.

In spite of two hundred years of history, the heart of Dublin still bears the mark of one man who, through his ruthless determination and vision, discovered the genius of one of Europe's greatest architectural talents. John Beresford's ghost will continue to shadow the streets and squares of the city, even if his name is eventually replaced by that of James Connolly in Beresford Square. At Abbeville, his daughters smile down from the wonderful murals, bearing witness to the past, and to the era of nobility and corruption from which the mansion emerged.

GANDON'S

TRANSFORMATION

1 7 8 1 — 1 7 9 0

At the rear of Abbeville, leading down from the house onto the generous lawns, there exist stone steps to which architects affectionately refer as the 'floating steps.' Seen from a distance at almost any angle across the parklands, the steps appear to hover over the ground, a feature which bears witness to Gandon's unique and often idiosyncratic genius. This is no accident, but one of Gandon's deliberate architectural quirks which he must have contemplated with a certain sense of aesthetic mischief as he stood in the fields of Abbeville in the 1780s. It represents his bold and highly original approach to building design, something only a craftsman of supreme confidence could have attempted, and something which the constraints of modern architecture would almost certainly prohibit outright. The 'floating steps' are just one of the strange details of Dublin's architectural heritage which makes Abbeville and other examples of Gandon's work so fascinating.

Anyone stopping to take even a cursory look the Bank of Ireland, formerly the parliament buildings, in the heart of Dublin will notice another one of Gandon's hallmarks, that of bricked-up windows. His use of 'blind' windows and the drum and dome at the Four Courts and at the Custom House are innovative and exclusively aesthetic non-functional features which only architects of great vision and design talent could risk. Along with Beresford who commissioned them, Gandon's creations themselves met with huge resentment and opposition, so much so that they earned him the nickname 'Architect Generalissimo.' Many people maligned him by saying that his creations were simply monuments to Gandon's own importance, a matter which puts these dominant structures into perspective, and demonstrates how original and overwhelming they must have appeared in Dublin of the late eighteenth century. It also

explains why Gandon's buildings were targeted in the fight for independence as key symbols of ascendancy rule. To this day, his designs remain unforgettable icons of Dublin's unique character as a city.

Wandering around Abbeville and its grounds, it is impossible to overlook Gandon's highly individual style. In order to understand the level of his creative mastery, it is interesting to investigate his background and the architectural milieu from which he emerged. Like many a genius, he shunned work, turning down smaller commissions which might fail to express the scope of his talents, preferring to drink himself into obscurity rather than surrender to the mediocre. He was an architect waiting in the wings for a big, imaginative project: Dublin.

While he lived in London, Gandon had been a pupil of Sir William Chambers, an extraordinary architect who had brought the audacious neo-classical style of architecture to London of the time. Under his tutelage, Gandon appears to have learned not only the rudimentary elements of this new building fashion, but also some of the pompous demeanour for which architects like Chambers became known. On the principle that he could never overestimate his own talents, Gandon felt it was undignified to seek commissions, and preferred people to come looking for him instead.

That he seemed to have a way of putting clients off, is the view expressed by his biographer Hugo Duffy. 'Up to the time he came to Dublin, his clients had never come back to him – not one of them.' Evidence of this can be seen in a letter of 23 September 1780 from a Mrs Montagu complaining that Gandon wasn't doing his work properly; that he was hopeless to deal with and a disappointment.

> I avoid letting Mr Stuart or Mr Gandon interfere in ye affair as from partiality to their glazier they wd find fault with the glass, besides they are so dilatory that they retard every thing instead of forwarding ye business of the House, & the trouble they give me by that means is intolerable.

Having picked up a degree of artistic arrogance, it seems that Gandon and Sir William Chambers were glad to part when he had reached the age of twenty-seven, but it wasn't until ten years later that he was offered the

post in Dublin. Gandon regarded himself as a genius, entitled by right to practically any commission, rather than having to work for it. A kind of artistic justice prevails in Gandon's life, however, since he really was a genius. In broad agreement with most architects and architectural historians, Hugo Duffy feels that Gandon had 'an extraordinarily accurate sense of proportion and balance. His buildings were dead on. He didn't seem capable of doing anything wrong. It was always exquisitely right and beautifully done.'

Sir William Chambers (1723-1796) never actually set foot on Irish soil but had designed Charlemont House in Dublin, now the Hugh Lane Municipal Gallery of Modern Art, as well as the Casino at Marino and the chapel and examination hall at Trinity College Dublin under the patronage of the first Earl of Charlemont. Gandon joined Chambers' office at the age of fifteen and worked on many exciting commissions during his years there. This experience undoubtedly formed the young man's vision as he went on to become Chambers' greatest pupil.

In *Vitruvius Hibernicus*, Edward McParland's study of James Gandon's work, the Dublin Custom House is described as 'the greatest tribute ever paid to Chambers.' He also remarks on the audacious design of the Custom House. 'The drum and dome is stupendous; it is mad and utterly useless. We are lucky to have a statement of the scale of architecture at its highest quality.'

It must have been some comfort to Gandon as he nervously stepped down from a packet ship in Dublin in April 1781, to know that this was the home of the Casino at Marino which his master had designed for Lord Charlemont. He had been familiar with its plans and would have cause to pass the Casino frequently on his way to Beresfords' country estate at Abbeville, in the townland of Kinsaley.

The Casino at Marino endures as an architectural gem and an aesthetic tribute to its patron, Lord Charlemont. It was said at the time that some of the stones that went into the Casino cost Lord Charlemont the price of a townland. They were imported and very beautifully carved. Hugo Duffy feels it is not an exaggeration to say that few other buildings in Europe could have cost as much per square foot. It was intended by Lord Charlemont to enshrine everything he regarded as culturally valuable; 'a

temple of art, a model little building that is decorative and beautiful to look at.'

On his arrival in Ireland, the Casino must have stood as a guiding spirit to Gandon, demonstrating the huge possibilities for an architect in Dublin, especially when backed by the patronage of the ruthless Beresford. Leaving his family and his debts behind in London, he set about the task of designing the new Custom House and Abbeville with great vigour. Despite his initial loneliness and the controversial circumstances of his commission, which forced him into virtual hiding, his creative talents finally found the scope which they deserved. It is unlikely that Beresford knew anything about Gandon's personal misfortunes, but he undoubtedly knew about the top class training which Gandon had received from Chambers.

Gandon was in his fortieth year when he arrived in Dublin and at this late stage in life, he must have been aware that this was his last and perhaps only chance at establishing a distinguished career. A sense of Gandon's nervousness around the time of his arrival in Ireland is felt in this letter written from Dublin.

> I found myself in a very unpleasant state of suspense apprehending the abruptness of my departure from my family and establishment in London might injure my character and, should my visit to Ireland prove unsuccessful, endanger my professional pursuits at home.

Gandon knew little however of the fierce hostility that his presence would arouse in Dublin, or the enormous difficulties he would face in building the Custom House. So sensitive was the issue that it took several weeks before it was considered safe for Gandon to visit the site for which Beresford had been secretly buying up land on the North Wall, away from the poverty and filth around the original, antiquated Custom House on the other side of the river. Gandon had also been cautioned by Beresford that 'this business must be kept a profound secret.' When work eventually commenced it was so hampered that it took ten years to complete the building.

The reception Gandon received on arrival in Dublin was extraordinary. He was brought immediately to Beresford's town house in Dominick

Street where he was confined for nearly three months, a period which Gandon himself describes as 'a kind of imprisonment', and where the only people he encountered were relatives of Beresford. It was probably at this time, in order to minimise speculation on his Custom House plans, that Beresford asked Gandon to consider plans for re-modeling Abbeville. Hugo Duffy feels that work on the house was carried out sporadically, with most of it being executed ten years after his arrival in Ireland.

'Abbeville was probably done in patches. Gandon would have had the builders occupy part of the house and when it was finished, they would decide what was to be done with the next part and that sort of thing. There would have been a lot of coming and going. I think Beresford also had plans for his residence in Derry, although I don't think Gandon ever completed the designs. I would say that Gandon was not paid for the work he did on Abbeville – I would think it was a 'thank you' job for getting such an important commission from Beresford. Of course when it came to the Custom House, Gandon received his money without question.'

A great amount of Beresford's letters to Gandon concerning the building of the Custom House were destroyed in 1830, on a ship that sank on the journey from Derry to London. One of the letters which survive, however, was printed in a book on Gandon published by his son. It demonstrates Beresford's conviction that all will work out to his advantage in the end but while waiting for that eventuality he wishes to engage Gandon on his country estate, Abbeville.

> Dear Gandon,
> Many thanks to you for your kind letter. I could not have a doubt of your sentiments as to me. I see great inquiries on foot, but they will all end to the confusion of those whose malice has dictated them. As things have turned out I shall not have occasion suddenly to remove.
>
> You may imagine that my mind is at present in a state of uncertainty, as I cannot, for a few days at least, foresee what may be the consequence of the turn things have taken. I shall, therefore, look to Aberville (sic) as my great object, and make it as comfortable as I can afford to do. I cannot say more on this subject

at present. I have received my letters from Ireland, by which I find you are to be deprived of Lord Fitzwilliam's presence.

Your's sincerely,

J B (*Life* 1795)

Gandon must have taken some solace that he could at least keep himself occupied in some way, if only to take his mind off the row that was brewing over the Custom House site. Once Beresford's plans became known, there were riots and attacks on the site, led by Napper Tandy of the City Council. Beresford wrote to Gandon frequently telling him to pay no attention to the 'foolishness' of the people. 'Build up the barricades and start off again as if nothing had happened and get that done straight away,' Beresford commanded his architect in his own domineering way.

During December 1785, every issue of the *Dublin Evening Post* published long letters denouncing Gandon and his work. One can only imagine the effect that this might have had on him, getting up every morning to find such vitriolic diatribe written against him. It must have threatened his practice and his standing among his friends until Beresford finally put an end to it. Gandon's employer was in a position to persuade Higgins, the proprietor of the newspaper, to make sure no more letters were printed. These letters were collected together, printed as pamphlets and bound into a book of which there is a copy in the National Library. 'The flow of invective is marvellous,' says Hugo Duffy. 'You couldn't imitate the hatred that's there.'

One of Gandon's greatest critics was William Burton-Conyngham, Teller of the Exchequer, who caused Gandon great trouble both at the building of the House of Lords and at the Four Courts. Even though he had invited Gandon to his estate, he attacked him after the Four Courts foundation stone was laid and said that 'if the building work was going ahead it would have to be pulled down.'

Another critic became so incensed by Gandon that he wrote, 'he is a depraved sensualist and a Machiavel.' Gandon himself recorded threats made on his life and he made a point of always carrying his 'good cane sword.' But the man who was to become undisputedly the greatest of all

Irish architects was to be dogged by criticism throughout his life in Ireland. In the end, however, the newspapers, that had been against him for so long, finally came around to admire the way the work was persevered with to the end.

Hugo Duffy feels that Gandon has been portrayed incorrectly as a man with a pleasant demeanour. 'I have the feeling that he was a disappointed man who treasured up every little irritation and dwelt on all the reasons why he was passed over in life. Of course much of it was of his own making, but a lot of people when it comes to their own miseries blame someone else. Gandon continued to blame others until the end of his life. He never forgot things. I don't know how embittered he was but I think he was an uneasy man. He wasn't happy. It's like the pearl in the oyster and perhaps that's part of the reason why his art was so great.'

In the book *Life*, based on the notes and diaries left by his famous father, James Gandon Junior leads us to believe that Gandon was an attractive and loyal character. The book was heavily censored, however, and contains many inaccuracies and editorial slips from which Hugo Duffy has been able to extract great insight into artistic life during the late eighteenth century, as well as the sense of loneliness and confusion that Gandon felt in Ireland.

'I believe that Gandon wrote his memoirs completely,' says Hugo Duffy, 'and his son didn't like a lot of what he read in them so he took pieces out. In fact he destroyed virtually all of his father's belongings as well. He wanted to pretend that Gandon was extremely respectable, when in fact he wasn't. Gandon came from a trade background, his father was a gunsmith and his father before him was a gunsmith. The worst thing of all was that the elder Gandon was a bankrupt and if people in Ireland had known he was the son of a bankrupt he would have been damned completely.'

One thing is certain: an extraordinary transformation was brought about by Gandon on his patron's country estate at Abbeville. According to David Griffin of the Irish Architectural Archive, who recently studied the walls of the house, the dairy was most definitely built at a later stage. Where the old house ends and the new one takes over remains an unsolved puzzle for architects. What they agree on is that the entrance porch, ballroom, dining-room and two bedrooms are Gandonian, along

with the lovely doorway and unmistakable 'floating steps' at the back entrance to the house.

An extract from the book *Beauties of Ireland* tells us that Abbeville is a '...fine mansion with extensive gardens and plantations. The house was principally erected by the Right Hon. John Beresford, after the designs of Mr Gandon. The gardens are perhaps the best arranged and the most extensive of any, in the vicinity of the metropolis. This place afforded an occasional summer residence to several of the lords lieutenant of Ireland, previous to the acquisition by the government of the vice-regal lodge (Áras an Úachtaráin) in the Phoenix Park.'

Gandon continued to live and work in Ireland for another forty years, until his death in 1823 at the quiet riverside retreat of his villa in Lucan. Due mostly to his son's bowdlerisation of his memoirs, there are a few curious and unexplained facts about Gandon's life. The correspondance with his close friend Paul Sandby was censored by either Gandon or his son; and mystery surrounds the death of his wife who was first believed to have died while Gandon was in London in 1782. He appears to have been making plans for his wife and family to settle with him in Ireland at the time. After the birth of her last daughter she died before leaving for Ireland. His son and two daughters apparently went to live with Gandon in Dublin, but accounts show that money continued to be paid out to 'Mrs G.' up until 1789, so it is possible that Mrs Gandon may have survived much longer than his discreet memoirs might have us believe.

'There is no record of his wife's death,' according to Hugo Duffy. 'The most extensive research was carried out by Edward McParland who noticed the entry on 1787 in Paul Sandby's accounts for a 'Mrs G.' Mrs Gandon must have been alive, although nobody knows what happened to her or where she disappeared to.'

There are other peculiar inconsistencies in our knowledge of Gandon's family. Hugo Duffy has come to the conclusion that there were two extra children who appear in his portraits, even though he can find no trace of them in the records. 'I have made an analysis of Gandon's love life over the years and have found that the period between the birth of one child and the conception of the next is regularly four months and thirteen days. However they managed that. Nobody seems to know why.'

It is a lot easier to assess Gandon's interesting architectural habits, such as his dislike for windows. In the book based on his memoirs, Gandon's son states that his father used to like drawing fortifications on his slate when he was a child in school. While a psycho-analytical interpretation might point to a deep-seated sense of insecurity which eventually led to such an idiosyncratic aversion to windows, a more generous assessment may also point to Gandon's childhood aptitude for architectural science.

Before he died in 1823 at the age of 81, he left behind a monument to his own genius. Gandon expert, Edward McParland, who has recently revisited Abbeville, points to the ballroom – or 'saloon' as architectural historian Maurice Craig would prefer to call it – as the most splendid and least known example of Irish neo-classical domestic interiors in existence. The dairy is also an extremely delicately refined building containing what McParland refers to as one of Gandon's prettiest drawings. 'The dry rectilinear elegance of the Abbeville stables and dairy display an architectural power unique at the time among Irish architects.' His transformation of the house from its original Elizabethan style is a seamless accomplishment, carried out in strange and tumultuous circumstances at various times between 1781 and 1790.

A B B E V I L L E A R C H I V E

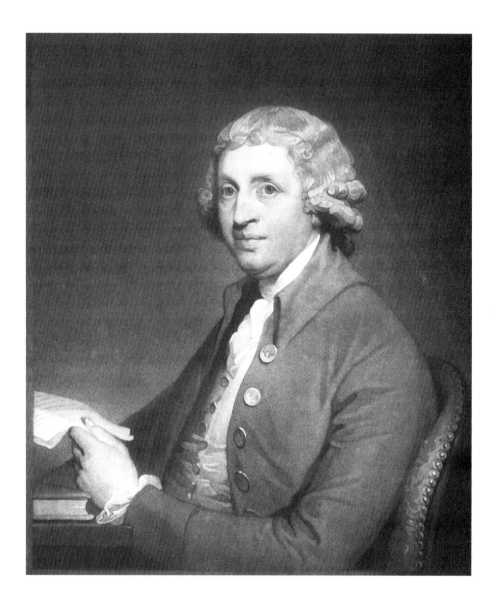

On the surface life seems to have been a masterpiece. Underneath it was a murky era of
cosy business arrangements, nepotism and land-grabbing. The Right Honourable John
Beresford, tax collector of Dublin in the late eighteenth century, commissioned Gandon
to redesign his gentleman's country villa at Abbeville.

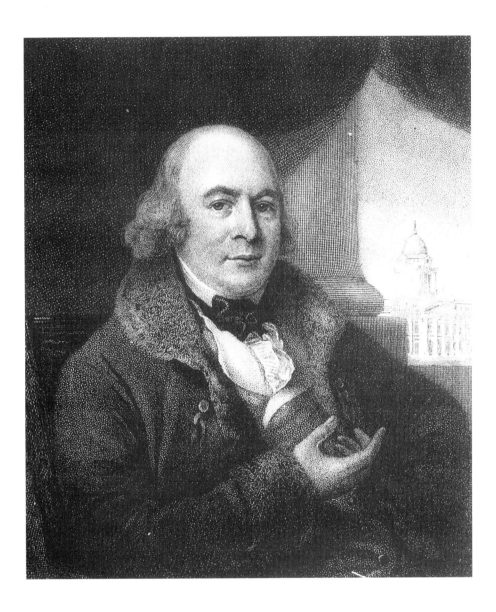

In his lifetime James Gandon shaped much of Dublin's skyline and was responsible for opening up the north quays with his Custom House – the building for which he is most renowned – and the Four Courts with its spectacular drum and dome.

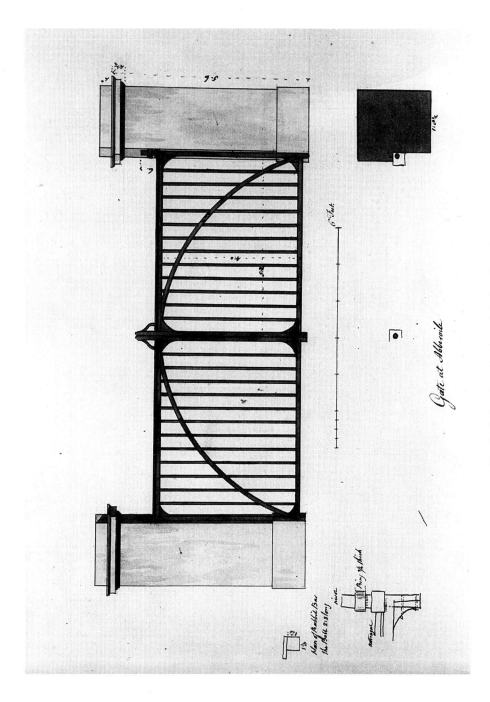

Gandon's drawings for the original main gate.

One of the surviving Gandon drawings of Abbeville. The rest were apparently burned in big bonfires at the front of the house along with leather-bound books and complete volumes of *The Times*, when the Cusacks moved out after a century in Abbeville.

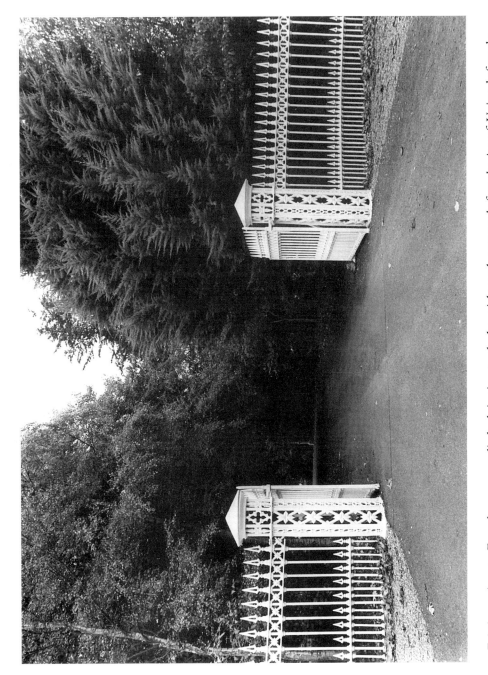

Existing main gate. From here on you slip back in time to the late eighteenth century, before the Act of Union, before the Great Irish Famine and the first glimmer of Irish independence.

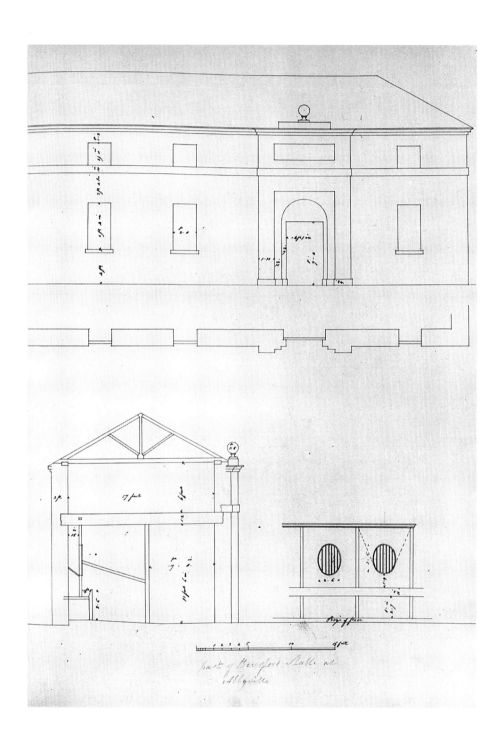

Gandon's drawings for the stables.

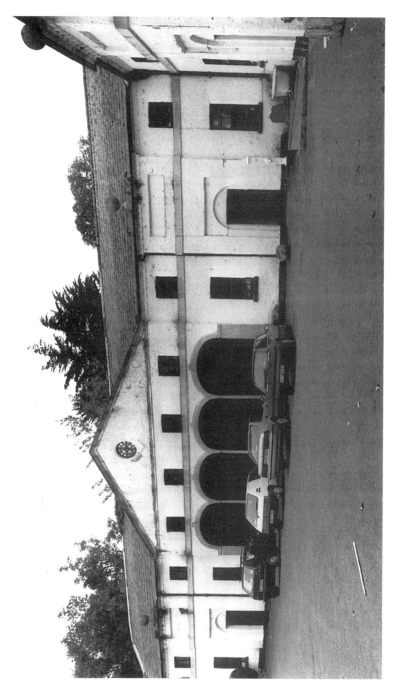

The elegant stables which are still in full use by the Haughey family turn what is esssentially a farmyard building into an architectural statement.

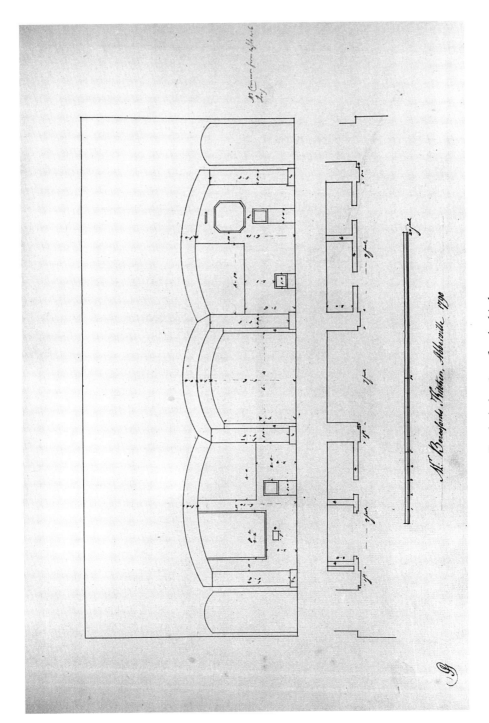

Gandon's drawings for the kitchen.

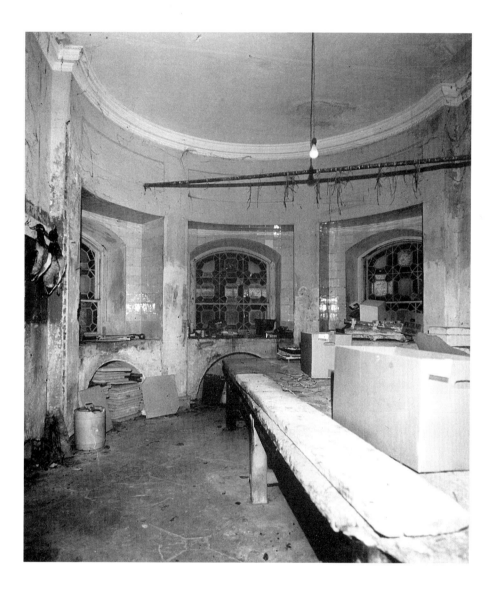

The dairy is 'one of the most exquisite of Gandon's designs and is admired by architects
for its simplicity and charm. The lovely stained-glass windows have
led to local people calling it 'the chapel'.'

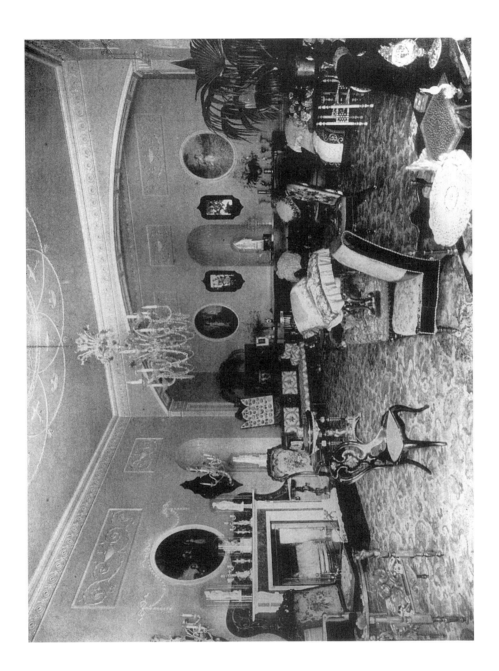

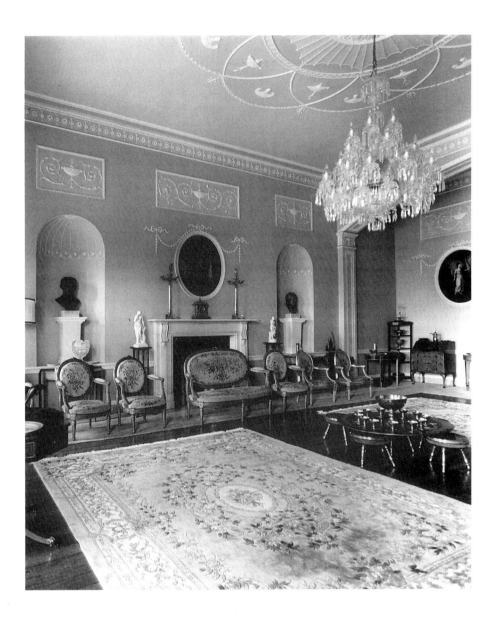

The ballroom at Abbeville in 1912 and 1992. Unquestionably the most impressive room
in the house, the ballroom is described by architects as the most splendid and least
known example of any Irish neo-classical interior. Gandon loved to use light and shade
resulting in niches and arches casting interesting shadows
adding overall depth to the room.

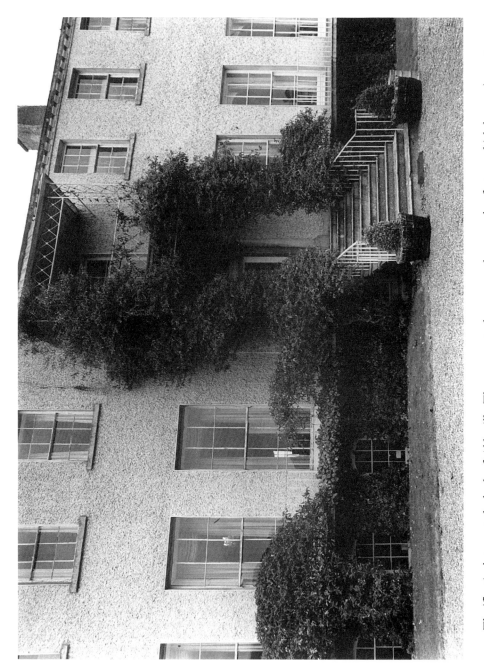

The 'floating' steps at the back of Abbeville. They appear to hover over the ground, a feature which bears witness to Gandon's unique and often idiosyncratic genius.

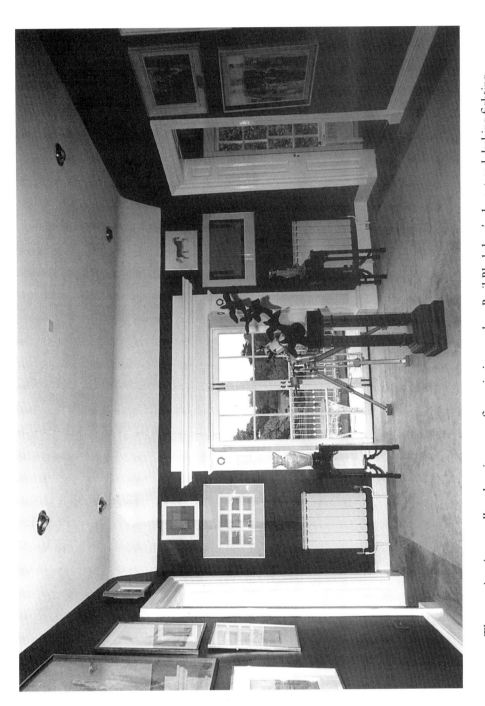

The upstairs picture gallery, housing many many fine paintings such as Basil Blackshaw's elegant and dashing fighting cock, Abbeville's lord of the farmyard. Haughey says he likes to be able to identify with works of art and is drawn to paintings where the subject or the place is familiar to him.

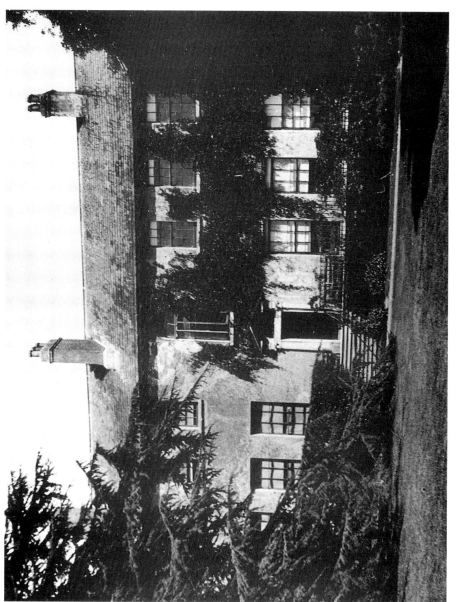

Everything reaches a great age at Abbeville. The back entrance with the great cedar, a picture which evokes the timelessness of the estate. Some of the trees on the land are three hundred years old and look set to live on for another three hundred. Haughey feels he will be around for a few more years himself.

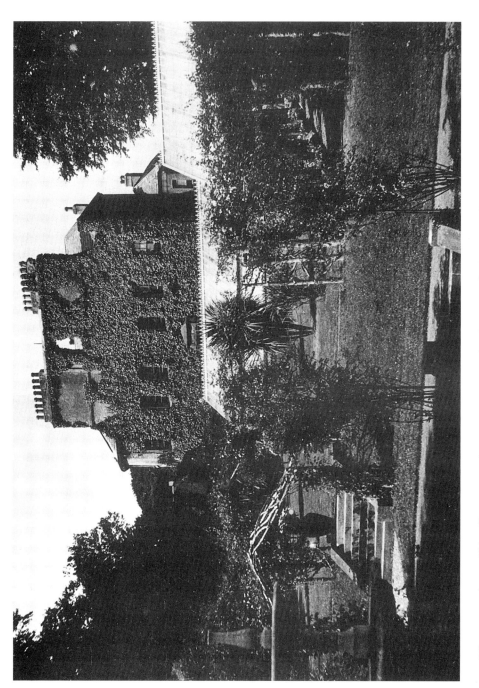

The rose garden at Abbeville in 1917. Queen Victoria is said to have sent for her bulbs from the Abbeville nurseries. The illustrious Ralph Cusack, nephew of Major Ralph Cusack, took this reputation for bulb growing a step further and became famous for his seed catalogues and his legendary wildflower bulbs.

Auctioneer's notice in *Country Life* 1958 when Abbeville was placed on the market by Percy Reynolds. It was eventually sold in 1963 and, despite huge restoration work carried out throughout the house under the direction of Michael Scott, only fetched a mere £25,000, even though it was bought in 1948 for £15,000.

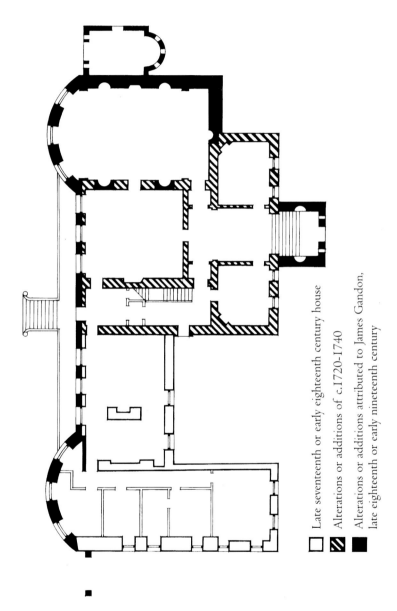

Ground floor plan (sketch) showing the different stages of architectural changes to Abbeville.
(After David Griffin, Irish Architectural Archive)

☐ Late seventeenth or early eighteenth century house

▨ Alterations or additions of c.1720-1740

■ Alterations or additions attributed to James Gandon,
late eighteenth or early nineteenth century

COOPER THE

ANTIQUARIAN

1 8 1 4 – 1 8 3 0

At both ends of the spacious hallway at Abbeville there are well-stocked libraries with which Charles Haughey has restored the tradition of bookishness and erudition that prevailed in the early nineteenth century when the house was owned by Austin Cooper. In the 1820s, Abbeville boasted one of the most priceless collections of rare and antiquarian books including an original copy of the *Annals of the Four Masters*, of which Charles Haughey now possesses a more recent edition. Today, the study, to the right of the hallway, is lined with bookshelves containing a wide variety of subjects such as history, politics, poetry, folklore, and natural science. In the words of Flann O'Brien, you could politely say that Abbeville is 'infested' with books.

The first thing you see as you enter the study is a large black and white photograph of Seán Lemass with his pipe in his mouth. Here too hangs a large and dramatic photograph of Eamon de Valera standing in a boat in Cork Harbour in 1938, as Ireland was handed back its ports. Underneath it there is a photograph of John F Kennedy addressing the Dáil in 1963, while over the door hangs a photograph of Charles Haughey with his son Seán as Lord Mayor of Dublin. Waiting to find a space are the recently rediscovered degree certificates of Charles and Maureen Haughey who first met while studying at UCD together. Every other inch of wall space is given over to books.

'Those three shelves are all poetry, and those shelves are all on Irish history,' points out Charles Haughey who has either read or made use of most of these books over the years. Along other walls he draws your attention to shelves which are devoted entirely to trees and birds. The table is also full of books such as the *Field Day Anthology*, while the

complete box set edition of the *Annals of the Four Masters* stands prominently on a sideboard nearby.

In Haughey's own office to the left of the hallway, there are further shelves of books, many of them rare and including sections on myth and mythology, entire shelves of dictionaries, books on historical buildings and countless reference books. Just beyond the stairs in the hallway, there are hundreds more books on horses, sailing and art. In the Malton room, the tables are piled high with books on Irish country houses, architecture and art. In the washroom next door to Haughey's office over the curved wash-hand basin area are more books — leather-bound editions of Turgenev, Hemingway, Steinbeck, Swift and Mann, while upstairs in the bathroom off the master bedroom, are stacks of biographies with that of Nelson Mandela on top.

'I have read most of these books,' says Charles Haughey, who has organised his library in such a way that he can virtually put his hands on any book immediately, 'and dip into them from time to time.'

Among the precious books on these shelves are the rare sketches, notes and diaries of Austin Cooper, a former owner of Abbeville who bought the house from Beresford's bankrupt son, John Claudius in 1814. The book entitled *An Eighteenth Century Antiquary 1759-1830* is a valuable historical reference text which offers fascinating insight into the Ireland of that time, when Austin Cooper held various posts including Deputy Constable of Dublin Castle as well as land agent and property manager. It was in his position as 'Paymaster to the Pensioners on the Civil and Military Establishments' that Austin Cooper travelled around the country making drawings and notes of significant monuments and buildings. His huge income also allowed him to build up a great library of ancient books, as well as buying the entire library of Lord William Burton-Conyngham who had been one of the main critics of Gandon's work.

One of the greatest curiosities that Austin Cooper discovered in this library was the last will and testament of Lord William Burton-Conyngham, who was previously thought to have died intestate. His estate devolved upon his nephew Lord Conyngham, while the will was found to have decreed an equal division of the estate between Lord Conygham and his mother. There is no record of Lord Conyngham's reaction to the news

when it was passed on to him by Austin Cooper and, more to the point, no information exists as to whether his mother got her share in the end. After Austin Cooper's death in 1830 the library was auctioned by his sons, an action described as 'unfortunate' by descendants who felt that Cooper's sons had no literary tastes. The sale of Cooper's entire library took place on 21 February 1831 at Maguire's Sales Room on Suffolk Street, Dublin. The total sum realised in the sale was £1968, the sales catalogue running to eighty-two pages and including many rare English and Irish manuscripts, coins and medals. There were nearly 1000 books listed, many dating from the mid-sixteenth century; if the library had remained intact it would have been priceless. His personal collection of rare books included a copy of *Archdall's Monasticum Hibernicum, Googe's Four Books of Husbandry 1586, Ferne's Blazon of Gentrie 1586* and the earliest, Venice-bound, red Morroco leather folio of *Aristophanus Comodeiae Graecae* dating back to 1498. Also in the valuable collection was the second book of the *Annals of the Four Masters (1171-1616)* which was sold to the Royal Irish Academy for £53 and on which John O'Donovan based his 1856 edition of the *Four Masters*.

The Cooper family in Ireland can be traced back to 1661, when Austin 'the settler' sold his possessions in England for the considerable sum of £1500 and came to live in County Wicklow where, according to legend, his feats of strength included overpowering two men, one in each hand, and preventing a horse and cart from moving forward while grappling with another opponent with his free arm.

Austin Cooper did not inherit this ability to perform such clownish acts and, in contrast to his great-great-grandfather, derived more entertainment from viewing old churches and graveyards, and collecting books. He was born on 15 February 1759, educated at Cashel and though he was first intended for the clergy, it seems his ambitions were altered by his friendships with the artist Gabriel Beranger and with William Burton-Conyngham, who founded the Antiquarian Society in 1780.

Austin Cooper married Sarah Mauvillian Turner, the daughter of Timothy Turner, a government lottery agent of Clare Street, Dublin, and they had seven children. Austin Cooper himself became a state lottery agent, winning a neat prize of £20,000 in 1796 on one of his own

tickets. This obviously helped with the purchase of Abbeville. He lived at 8 Clare Street and in 4 Merrion Square North in Dublin, before buying Abbeville as his summer home. In his diaries he states that on 'Friday 11th August, met the sub-sherriff at Abbeville to get possession' though he could not reach an agreement on that date. On Tuesday 15 August 1815, he records that 'Mr Faris and I went to Mr Sayers to breakfast. Met the sub-sherriff after who gave me possession of Abbeville.'

Taking over from tenants H and J Batchelor, Esq who occupied Abbeville for a short period, Austin Cooper records his arrival with his daughter 'little Sally' at the newly purchased estate on Tuesday 15 August 1815. On the following Saturday he writes that the 'Kinsaley Tenants had a bonfire to celebrate the occasion of coming to Abbeville with Musick etc.'

Cooper acted as land agent and property manager for various landlords such as the Colonel Talbot, later Lord de Malahide. On the spectacular income which he earned from this, he soon began to increase the estate around Abbeville, buying up land all around him until it amounted to 473 acres and produced an annual income of £1500 a year at the time of his death in 1830. His income for the year 1803 came to an estimated at £3700 – an enormous sum in those days.

In 1829, Austin Cooper of Abbeville met with an accident in his carriage when the horses took fright and bolted. The carriage overturned along the route from Abbeville to Merrion Square and he sustained a fractured leg from which he never recovered. He died on 30 August 1830 and remains interred in the fine Cooper family vault in St Nicholas churchyard in Kinsealy, which he had built in 1813 and which remains well conserved.

The cause of his death can be indirectly related to the bad road conditions in north Dublin at that time. One description of 1802 laments the existence of '...round smooth stones as large as a man's head, rolling about the road ... laming horses and breaking the springs of carriages, until stopped by the ditch, or are scraped off in the mud.' Austin Cooper's diary of 1830 records his rapidly declining health only three months after his wife's death.

> June 7th: Sally departed this life about 5 mins before 5 o'clock this
> morning perfectly quiet. June 10th: Attended my dear wife's funeral

this morning at Kingsaley (sic) accompanied by several of her family relations. Went to Abbeville after, returned to dinner bringing T Dickson and little Austin with me. June 19th: Taken very ill in the course of this day running a very feverish heavy cold and went to bed about 3 o'clock taking nothing. June 20th: Sat up part of the day but soon returned to bed. July 10th: My knee was laid open and a great discharge. 15th July: Another part of my knee was cut open. July 20th: Executed my Will this day.

During his lifetime, Austin of Abbeville was in a position to lend a staggering sum of £26,000 to Richard Sayers, a relative of Lord Talbot de Malahide. As a result of non-payment of these debts, Abbeville was sold off after Cooper's death, and his profligate sons went on to sell most of his estate. The editor of *An Eighteenth Century Antiquary*, Liam Price, stated that 'after his death his sons unfortunately took no care to preserve his papers and as a result many were lost.' Of the fifty-two diaries only twelve remain in the family today. Many of the surviving Cooper papers are now in the possession of the National Gallery in Dublin.

Among Austin Cooper's papers is the following piece of fatherly advice which his sons clearly failed to read:

> What profit pedigree or long descent from far fetch'd blood or painted monuments of our great grandsires visage, tis most sad, to trust unto the worth another had, to keeping up our farms, which else would fall, if besides birth there be no worth at all, for who counts himself a gentleman whose grace, is all in name but otherwise is base, or who will honour him the honours shame, noble in nothing but an noble name. It's better to be meanly born and good, than one unworthy of his noble blood, though all thy walls shine with thy pedigree yet 'Virtue only, makes Nobility.' Then that your pedigree may useful be, search out the virtues of your family, and to be worthy of your father's name, learn out the good they did and do the same, for if you bear their Arms and not their fame, those ensigns of their worth will be your shame.

After Austin of Abbeville's death, the estate amounted to £29,000 and fell to his two sons, John Turner and Samuel. His wishes for the estate to remain in the family name did not materialise, and from notes written in

1877 by a direct descendant named Dr Austin Cooper, we are told of a wanton disregard for their father's final hopes. No sooner had their father died, they 'commenced a career of dissipation, extravagance and folly not to be surpassed.' Having recklessly wasted and misused the amount of £9000 of their father's personal estate, a suit was instituted against them in 1844. Three hundred and eight acres of land were sold for the sum of £19,200, followed by a further section of 66 acres sold for £15,100 in 1857, leaving only two lots of 84 and 85 acres each, of the once vast estate in the Cooper name.

One of his sons, Sam Cooper, appears to have had problems of a more personal nature as well. He had left his second wife and taken on a new partner while doing his best to avoid his first two wives. He was also having difficulties with several of his Irish tenants on his lands at Kinsealy, in particular a tenant farmer named Dunphy who would not pay his rent. His older brother's spending sprees meant that as trustee of his father's will he was jointly responsible and liable to pay his father's 'just debts', an onus which ultimately sent him into exile, escaping to the Isle of Man and elsewhere out of the jurisdiction of the courts. He changed his name to Browne, an action which greatly hampered the pursuits of his genealogist descendant Richard Austin-Cooper, who eventually traced him to Belgium and Germany.

Curiously, although Austin Cooper had donated the land for two Roman Catholic Churches in Kinsealy, he was noted for his anti-Catholic sentiments. He was a staunch Protestant and when his eldest son William married a Catholic, he was cut out of his will. In an entry written by Austin in his diary on 17 November 1784, he demonstrates his bigotry by denouncing intermarriage as 'portending to the Ruin of the protestant interest.'

At this turbulent pre-famine period in Irish history, feelings were running high against landlords and their agents, many of whom were targeted by the Catholic peasants who resented the good living of the upper classes while they and their families went hungry. In a climate of poverty and constant evictions and home burning for non-payment of rent, a Tipperary member of the Cooper family was murdered in April 1838. He was shot dead in an assassination bid on a fellow traveller. Richard

Cooper writes about the incident as a 'profoundly shocking event' for the family. Although they belonged to the Protestant ascendancy, they 'were always kindly landlords who charged fair rents, or indeed no rents at all in the time of famine. They created work by the building of a folly at Castletown House and gave land for the construction of Roman Catholic churches for their tenants.'

In a letter written shortly after the murder of his younger brother, Sam Cooper of Killenure Castle, County Tipperary describes the day on which they were in the company of a Mr Wayland, the land agent who is believed to have been the target of the attack.

> In March 1838 Mr Wayland ejected a man named Ryan for non-payment of rent. My brother interfered and got this Ryan his house and two acres during his life. Ryan's son, not wishing to be deprived of the land (previously held), got up a conspiracy against Wayland. I was with my brother on our way to the Fair at Tipperary. He was driving. Mr Wayland joined us not two hundred yards from the place of the attack. I was armed with a double-barreled gun as I went for the protection of my brother, who as a Land Agent, had been threatened previously. Mr Wayland rode at the off side of our Gig.
>
> We were a mile from home when three shots were fired at us on the near side. I jumped out of the Gig and saw three men with their faces black and otherwise disguised. Two were re-loading and I fired at the third, who immediately put his hands up to his face and dropped the gun. The others ran away, I turned to see what was the matter with my brother, who I'd expected to join me, when I saw him hanging quite dead out of the Gig. I saw Wayland rising from the ground saying he'd been hit when a fourth man came forward and fired as I went to Wayland's assistance. Wayland fired a pistol at the man, who then fled over the fence with the rest. I fired a second shot at their heads and heard since that I drove the shot into the fellow's hat. They didn't go until they saw me reloading which I pretended to do since I had no ammunition.
>
> I got Wayland into the Gig (as his horse was shot in the head) and down to Mr Smithwick's of Lacken. I have no doubt that the attack was intended for Wayland and that the fellows fired through us at

him. The man I fired·at and also the man that fired the last shot have been executed. The subscription for their apprehension amounted to £4000 which was paid every farthing (a thing not usual in Ireland). My brother was very much liked in that part of the country, was very charitable and has left a widow and four children.

Richard Austin-Cooper, who has written the history of the Cooper family still possesses a gruesome reminder of the murder in the form of several pieces of Sam Cooper's shot which were dug out of the murderers' bodies after they had been apprehended and hanged. In his book *Butterhill and Beyond* he describes a visit to Abbeville in 1973 during which he met Charles Haughey. His view of the present owner of his ancestor's home is that of a 'self-made' man.

'I have met Charlie Haughey on several occasions over the years, always, admittedly, on his home ground; Abbeville House that is, where my branch of the Cooper family lived between the years 1814 and 1830 ... I have always found 'Charlie' welcoming with a ready smile and open-handed hospitality. One might think that an Anglo-Irish Protestant 'Ascendancy' family such as ours would be *personae non grata* to a Roman Catholic man of politics.'

In fact, Charles Haughey shows a great awareness for the history of Abbeville and is very keen on preserving the memory of its former owners. In April 1973, Austin-Cooper received a letter from Haughey inviting him to visit the churchyard of St Nicholas in Kinsealy, as 'the place has been tidied up.' This was in response to Austin-Cooper's expressed concern that the tomb of Austin Cooper and indeed the entire churchyard was '...a shambles, with jungle-like growths and toppling tombs.' When he arrived the following year on a short holiday with his wife, they were given a warm welcome by 'Charles of Abbeville' who invited them in for tea, but first insisted that they should view the graveyard in which Austin of Abbeville was buried.

'I could not believe my eyes' writes Austin-Cooper. 'Not only had the grass and hedges been cut and trimmed, but new gleaming white paths had been laid and tombstones straightened and, if not exactly polished, they had certainly been cleaned. He had obviously taken my remark very seriously and, no doubt, a word from the Taoiseach in the ear of a local

councillor had more weight than a dozen letters I might have written…He simply had it in his power to do a good turn and took the trouble to go out of his way to see that the work was done.'

THE CUSACKS OF

A B B E V I L L E

1 8 3 0 – 1 9 4 0

There were goldfish in the pond and pheasants on the lawns. In summer, the 'pock' of the cricket bat drifted in from the cricket oval. The Turner greenhouse was the largest in Ireland and in winter, the walled-in peach orchards were heated to maintain a semi-tropical outdoor climate. Electricity for the house was generated from a reservoir on the lake nearby. With dozens of gardeners, livery men, housemaids, wet-nurses, cooks and domestics, the estate thrived for a century in a frenzy of industry. Servants polished the stone steps with bars of soap and kept the laundry presses stocked in order of calendar months. In the grounds there was a cats' and dogs' graveyard and inside they kept a museum with stuffed monkeys, bears, birds and tigers. The house was full of artefacts brought back from India, and at bedtime the children read *Kim*.

For a hundred years, from the 1830s until the mid-1940s, the Cusack family lived at Abbeville in a lifestyle of charmed perfection. As stated earlier, after the Coopers the house and lands came into the possession of Sir James William Cusack, surgeon in ordinary to Queen Victoria, swelling to an enormous domain of 2000 acres and remaining in Cusack hands until after the founding of the Irish Republic. No matter what happened outside the boundary fence during these years, the Cusacks of Abbeville lead an insulated and virtually self-sufficient lifestyle, living out the last days of that golden age of nobility until the Land Act of 1923 dispossessed them of three-quarters of their land.

Looking back at this bygone era of splendour, it is hard not to think of life at Abbeville without a certain sense of nostalgia. Notwithstanding the famine years and the subsequent War of Independence, during all of which the Cusacks had their seat here, it remained a family home with an

extraordinary history of its own. Away from the turbulent politics of Ireland and Europe, the occupants retained a strong sense of dignity and loyalty towards the Crown, in the belief that they were upholding the best of British traditions, bringing a superior culture to the colonies. After all, it was the tail-end of an era in which there was a certain sense of innocence and pride attached to colonialism and imperialist expansion, an era which really only came to an end with the Second World War. At Abbeville, the ante-room, now called the Malton room, was filled with Shivas and other ornaments brought back from the Raj. The ceiling of the upstairs landing was painted with medals of the order of the British Empire and the house contained a museum of uniforms from the early Irish regiments such as the Enniskillen Dragoons and Royal Irish Fusiliers. A view from inside Abbeville during the Cusack time contains the most compelling picture of the Irish 'big house' over a century.

Starting with James William Cusack, who bought the property for his eldest son Henry Thomas Cusack in 1830, the estate went through many owners. On Henry's death it passed to Athanasius Francis William Geoffrey de Geneville Cusack, otherwise known as 'Bimbo', a man who was said to be fond of the drink and died in 1887, at the comparatively young age of thirty-two. Abbeville then came into the hands of his brother Major James William Henry Claud Cusack, otherwise known as 'Piccolo.' On Piccolo's death the house was passed on to Major Ralph Smith Oliver Cusack who, with his wife Mabel, began to show a greater interest in travelling extensively around Europe and living out of the boot of their car than staying at home on the estate. His grandfather, after all, had been a titled shareholder in the Great Western Railway. Ultimately however, the Cusack era at Abbeville went out with a bang and a whimper, first of all when the 2000 acre estate was reduced to 600 acres by the Land Act of 1923, and finally with the exploits of Major Ralph's nephew, Ralph Desmond Athanathius Cusack, the famous horticulturalist and author of *Cadenze* who seems to have devoted himself to the high life, spending his last years in the south of France where his children still live.

Robert Ralph Cusack Jobson is one of the last surviving members of the 'senior branch' of the Cusack clan in Ireland. Having lived in Abbeville as a young boy, he can recall the atmosphere of grandeur and elegance which

prevailed during its heyday, even though he has never gone back there since. In his eighties, believing that a return visit might undo his fine memory, he is still able to cast his mind back faithfully to the glorious days when Abbeville was a hub of activity.

Jobson's mother was the sister of Major Ralph Smith Oliver Cusack. She died when Jobson was only three years of age, whereupon he went to live in Abbeville, then owned by his great-uncle Henry 'Piccolo' Cusack. He was looked after at Abbeville by his mother's sister Violet, whom he describes as the 'unpaid chatelaine' of the house. Among his possessions, Bob Jobson has an early photograph of his mother beside the fountain which, in those days, stood at the end of the big stone pergola with huge white steps leading to a pond. 'I remember feeding the goldfish. My uncle Piccolo would give me a packet of ants' eggs. It was great fun for a little boy. These goldfish were enormous brutes.'

Along with the cricket oval in front of the main door of Abbeville, there was also a polo field on the estate, as well as a larger cricket field opposite the gate lodge at the entrance to Abbeville. Bob Jobson remembers with fondness the matches and the great numbers of people who lived in surrounding big houses, many of which are no longer there. Lord Talbot de Malahide was a regular visitor. 'Old Jim Talbot would come around every Sunday and sit on one of the leather couches in the billiard room and go to sleep.'

To this day, Bob Jobson can walk you round Abbeville from memory, starting with the sandstone steps inside the main door which used to be damped and rubbed with a huge stone block of Monkeybrand – 'like Vim in a block.' He describes the hall as 'squarish but not large.' On the floor in the middle there was an exquisite mosaic in the shape of a big belt, beautifully designed with a buckle and a big mastiff dog bearing the Latin inscription '*Cave Canum*.' Sadly, this magnificent mosaic floor is one of the Abbeville features which disappeared in the 1940s when architect Michael Scott replaced it with a wooden floor.

Jobson recalls the big mahogany door straight ahead which led into the dining-room. To the right there was a lobby and 'quiet door' for servants to enter the drawing-room which was on the extreme right of the house. On the right as you came up the stairs into the hall was 'Uncle Piccolo's

study' where the pictures of de Valera and Lemass now hang. On the left was the breakfast-room, which was entered through the butler's pantry at the foot of the stairs. 'There was also a lovely bathroom with marvelous big basins. Both the loo and the basins were made in the most beautiful old willow pattern. It always fascinated me, a huge basin; the old bridge and the willow tree. A lot of these things of course would be priceless. The faucets were made of gunmetal, not brass; that lovely deep gold colour of the old gunmetal.' Many of these features have also disappeared since the Cusacks left Abbeville.

In those days, all the water came from the lake. The lake also provided water for the electricity generator or the 'ram house' where Jobson used to go and court his wife-to-be. 'It was the only place we would get any peace. You'd hear the ram going 'brroomm broom' and you'd know they were pumping water up to the house.'

At the end of the staircase Jobson described a narrow hallway leading to a backdoor. 'Now that was a true Gandon door, pure George the Second,' says Jobson. To the right he remembered the dining-room as a 'wonderful cube of a room, very nearly square and very high. In its heyday there were fifteen madonnas in it, all Italian except for one which was North German. There was an enormous Cusack Tryptych by Carlo Dolce and colossal panels from the Cassoni coffers painted around the 1300s.' His Uncle Ralph sold a lot of this collection shortly before he sold off the whole place. Other items were distributed among the family.

The ante-room, now the Malton room, was situated in the very early part of the house and referred to by the Cusacks as the Jacobean part of the house. Jobson remembers the wonderful early carvings of Shivas that his uncle had brought back on one occasion in a consigment of thirteen tons of material from India. Shivas were all over the house, in his study, in the front hall. 'The lady with the four legs and the five arms.' There was also an enormous lacquer case along the left hand wall, ' a very early Indian artefact.'

Behind a closed-off archway was the housekeeper's room where all the 'holy of holies' were kept, along with the 'goodies.' Jobson recalls how the housekeepers kept slates on which the cook would write down what she needed. In those days the kitchens and the laundries were huge. 'One of

my escape routes was to the laundry,' Jobson says. 'I'd go down to my greatest chum who was an old lady in the laundry called Lizzy. There were four huge boilers. The sheets were all laundered and calendered, and these wonderful women were starching everything. Enormous drying racks were pinned into the wall for the heavy sheets. There was a huge amount of staff, housemaids all over the place upstairs. Lizzy was my pal, she'd give me bull's-eyes or peggy's leg, or a lovely toffee bar. She was a dear old lady and I spent a lot of time with her, she was in charge of the laundry. She'd let you play with all the lovely old threads, all different colours in the baskets.'

For a little boy of three, Abbeville, with all its daily rituals, must have been an extraordinary place. In the early mornings he recalls, as a small boy, walking into the morning-room and seeing the rows of cooks and domestics kneeling down for prayers. These were led before breakfast every morning by Uncle Piccolo. When he was older he was given the job of opening the Bible at the correct reading every morning. One morning he left the Bible upside down and nothing was said until after breakfast when he was called into Uncle Piccolo's office, to the right of the main hall, and told: 'Don't be lazy, thank you.' It may appear funny now, explains Jobson, but there was a correct procedure which had to be followed through faithfully, otherwise 'you got mildly ticked off'.

Uncle Piccolo was a quiet, but colourful character and Jobson remembers him driving a dogcart with two horses, one in front of the other, in tandem. 'It was a rather lovely way to be able to drive. He would sit up and had his tiger (groom) behind him. He was a great whip and could drive through the eye of a needle.'

The Cusack family first settled in Ireland in 1150. The name 'Cusack' is not originally Irish. Geoffrey de Cusack, originally from Normandy in France, came to Ireland to arrange a marriage between Strongbow, the Earl of Pembroke, and the daughter of an Irish Chieftain by the name of McMurrough. He travelled over from Wales and landed on the Wexford coast before travelling to McMurrough's estate. He settled in Ireland and died later at the age of twenty-seven at the Battle of the Boyne.

Sir James William Cusack who bought Abbeville in the 1830s came from one of the oldest of the Leinster families and owned a vast amount of

property. He was an eminent surgeon to Queen Victoria and President of the Royal College of Surgeons whose town house was situated on St Stephen's Green. It later became known as the Kildare Street Club, and now bears a plaque in his memory. He owned big properties in Counties Meath and Westmeath, as well as the houses around Abbeville including Bohomer, Emsworth, Greenwood and all the houses along the left-hand side of the Malahide Road. He also owned huge tracts of land in north Dublin including part of Lord Talbot's woods, way out beyond the Swords Road. His 2000 acre estate ran from old Portmarnock Church to Cloughran, taking in all the villages of north Dublin.

After the death of his wife, James William Cusack invited his brother Samuel and his family to come and live at Abbeville. Doctor Samuel Cusack had two children, a boy and a girl. The eldest child, Margaret Anna, was to become internationally famous as the 'Nun of Kenmare.' After her parents separated Margaret Anna went to live in England with her mother. When her fiancé died of a fever she became an Anglican nun. Soon after that, she converted to Catholicism and she joined the Sisters of Penance. In 1859 she moved to Newry, County Down, where she joined the Irish Poor Clare nuns. Some time later she opened a convent in Kenmare, County Kerry where she worked on behalf of the poor. With a keen interest in politics and history, she went on to write, as explained earlier, many highly controversial books. She later went to live at Knock, County Mayo and expressed some doubts about the appartition there, having discovered that Father Cavanagh's housekeeper, to whom the apparition first appeared, had a fondness for the drink and was accustomed to seeing wonderful things.

Margaret Anna, now known as Sister Mary Francis Clare, went to Rome in 1884 where she obtained permission from Pope Leo XIII to found the Order of the Sisters of St Joseph of Peace. She encountered great opposition from the Catholic clergy and eventually resigned from her order and from the Catholic Church. After trying different Protestant churches she again became an Anglican. It was only in 1974 that Mother Francis Clare was officially recognised as the Founder of the Sisters of Peace. She died on 5 June 1899 at the age of seventy. Robert Cusack Jobson believes that the 'Nun of Kenmare' never actually lived in Abbeville, though her biographer Irene Ffrench Eagar states that in

Margaret Anna's memoirs, she mentions how she loved Abbeville and lived there with her mother for a few years, up to the age of nine.

Sir William Cusack gave Abbeville to his eldest son, Henry Cusack, who lived there for many years and had two sons. In those days, it was often a custom to 'save the wife and employ a wet-nurse for children.' Their wet-nurse was a Signora Seppi, from an Italian family in Dublin. She looked after Uncle Piccolo and his older brother, affectionately called Bimbo. Like many of the Cusacks, Bimbo was very tall, around six foot four. 'He drank a lot and had trees cut down for drink, quite a wild man. He died, I suppose, of liver poisoning, and his brother Piccolo came in for Abbeville.' Jobson's Aunt Violet remained in Abbeville. She spent each spring near Interlachen in the Swiss mountains painting the wildflowers. She illustrated for an English gardening paper called *Veronica.*

At the head of the landing on the right was the animal museum where Uncle Piccolo kept his stuffed monkey. The dogs who lived on the estate were also skinned and stuffed when they died while their bodies were buried in the graveyard along the walk up to Greenwood, each with their own individual tombstones. This graveyard still exists today.

A spiral staircase led up to the servants' quarters where the housemaids stored the sheets, pillows and towels. At the end was the library or book-room where Jobson recalls Aunt Violet reading to him. Up the steps were the two master bedrooms with separate entrances for Uncle Ralph's room and Aunt Mabel's room. In another room they kept the uniforms in rows. This museum of early Irish regiments was eventually bundled together and handed over the British Forces; 'field uniforms, full dress, mess dress, all beautifully made.'

The billiard room is where Jobson's Uncle Piccolo and his aunt spent most of their time over the years. He recalls the wonderful old billiard table made by Burroughs and Watson, and which on occasion was used as a bed. From there, they would send the young boy off on various missions, either to find Aunt Mary or to go and visit Aunt Bessie who lived upstairs in an enormous room with two fireplaces.

Jobson fondly remembers the Gandon-designed dairy which was finished in Wedgewood plaster. It was still in working order and being used for the

household. 'The dairymaid or one of the men used to bring in the milk. It might have been old Curran the gardener.' The milk was left to cool and then went through the process of the separators in huge cream vats. All the butter was made for the house and every day the different quantities of butter had different seals on them, 'wooden seals with carvings of flowers or cows or some blinking thing. So you would know Monday's butter or Tuesday's butter. Those were the days when they had a big staff in the house.'

On the lawns of Abbeville there were peacocks, one of which was 'pure white' and known as Beelzebub. 'There was a great amount of peacocks, and often so many peahens that we had to shoot them. There was great eating in the peahens. Roast peahen was a great treat we'd have at Christmas.' The wildfowl roosted in a great old cedar tree which grew at the back of Abbeville until the great storm of 1903 knocked it down. The gate lodge of Abbeville was destroyed in the same storm by an enormous beech tree, one of many other trees that fell. Charles Haughey recently found a brass plaque dating back to that time bearing the words: 'These Cedar Pillars and Balusters, and the Yew Hand-Rail, were made from Trees which fell here in the Great Storm 27th Feby 1903.' This plate was attached to a staircase in the hallway which has since been altered.

The last Cusack owner of Abbeville was Robert Jobson's uncle, Major Ralph Smith Oliver Cusack. After pursuing a distinguished career in the British Army, he seems to have been more determined to live out the end of this era of nobility in a blaze of glory, spending most of his time on the continent. He owned enormous cars – 'big old touring Didion Boutons, magnificent French cars, big American Buicks, always coupés with a huge boot because he travelled an awful lot.' He and his wife Mabel lived almost entirely in Europe. They would leave for France and Italy, or go to Switzerland where they lived for years in the Hotel du Lac. Jobson recalls how his uncle would leave him behind to look after Abbeville. 'We're off. We're going away and we won't be back until September,' he remembers them saying, leaving him in charge. There were only about three gardeners then, where there used to be eight. 'My uncle then sold the outfarms, getting ready to close down the whole place. During the Emergency there was no petrol; the Emergency had me absolutely

banjaxed. I had to travel in a bus, walk down from Abbeville, often in the dark.'

Major Ralph Cusack had no heirs and he eventually sold the estate to Percy Reynolds. His illustrious nephew Ralph Cusack became famous for his book *Cadenze* and his Bohemian lifestyle. Though he never actually lived in Abbeville, he became a celebrated figure on the Dublin literary scene during the time of Brendan Behan and Patrick Kavanagh and seems to embody the end of the ascendancy line, when aristocrats began to live on their money and turn to artistic endeavours. 'What is one to do when one has a certain amount of money, is an immensely civilized and intelligent man and rejects religion, 'a career' and the bourgeois conventions? Surely art is the answer?' writes the poet and biographer Anthony Cronin who recalls some of his encounters with Ralph Cusack in his memoir *Dead as Doornails.*

The latter Ralph Cusack could be described as one of the original hippies, a 'very wild' individual who spoke six or seven languages and lived in Wicklow during the 1940s, when Ireland became a refuge for the kind of person Anthony Cronin refers to as 'non-combattants, sensitives and progressives of one kind or another…' Ralph Cusack was a modernist painter and a well-known horticulturalist whose seed catalogues were renowned for their wit and curious style. There is a story of Brendan Behan once waking up in the garden shed and eating his rare lily bulbs, having mistaken them for onions! His wild flowers became famous and enthusiasts arrived from all over Europe to purchase bulbs of some rare Himalayan or Andean species. But Patrick Kavanagh referred to him as a 'phoney' and his legendary bulb-growing was said to consist of nothing more than a clever gentleman's racket which involved importing bulbs from Holland and passing them off as genuine wildflower bulbs, an enterprise designed to produce money when the capital was beginning run out.

The style and grandeur of the Cusacks' way of life at Abbeville had come to an end. What devastated the whole place was the Land Act of 1923 under the government of the Free State when three-quarters of the land was confiscated. Robert Jobson describes how the land was taken away

and given to various families like the Kettle family of Kettle Lane. Greenwood, a dower house on the Abbeville estate disappeared subsequently under the Reynolds' tenure, when it was allowed to go to ruin and was eventually demolished, in spite of the fact that it had an extraordinary character and history. The composer Handel had stayed there while the Messiah was first performed in Dublin; subsequently there was a charming walk along the lake between Abbeville and Greenwood known as 'Handels' Walk.'

Many other features of Abbeville have also disappeared since then. In 1940, an oak farm in Feiltrim was cut down when Roadstone took over an area for quarrying. They were also said to have been responsible for demolishing a very unique and historic landmark, an ancient windmill which went back to the earliest Ordnance Survey maps of Kinsealy and became an important marker on the admiralty charts. Abbeville itself was built with 'beautiful old rose-coloured brick' while the middle section was done in limestone but was later covered with pebbledash. The British army medals on the ceiling in one of the rooms were covered over during the renovation by Michael Scott with a stippled ceiling.

'I don't know why my uncle sold Abbeville to Mr Reynolds,' says Bob Jobson. 'It's all changed so much now. I don't want to visit Abbeville. I was very, very fond of the old place and am a little sensitive about going back.'

CONTEMPORARY COLOUR PHOTOGRAPHS

of HOME and FAMILY taken by

JACQUELINE O'BRIEN

1 9 9 6

Abbeville rises out of quiet Georgian parklands, a magnificent stately home, set among the north Dublin farmland in Kinsealy, seven miles from the city centre. The house encompasses all the turbulence of past centuries passing from numerous ascendancy families to successive Irish Catholic families and finally into the hands of former Taoiseach Charles J Haughey.

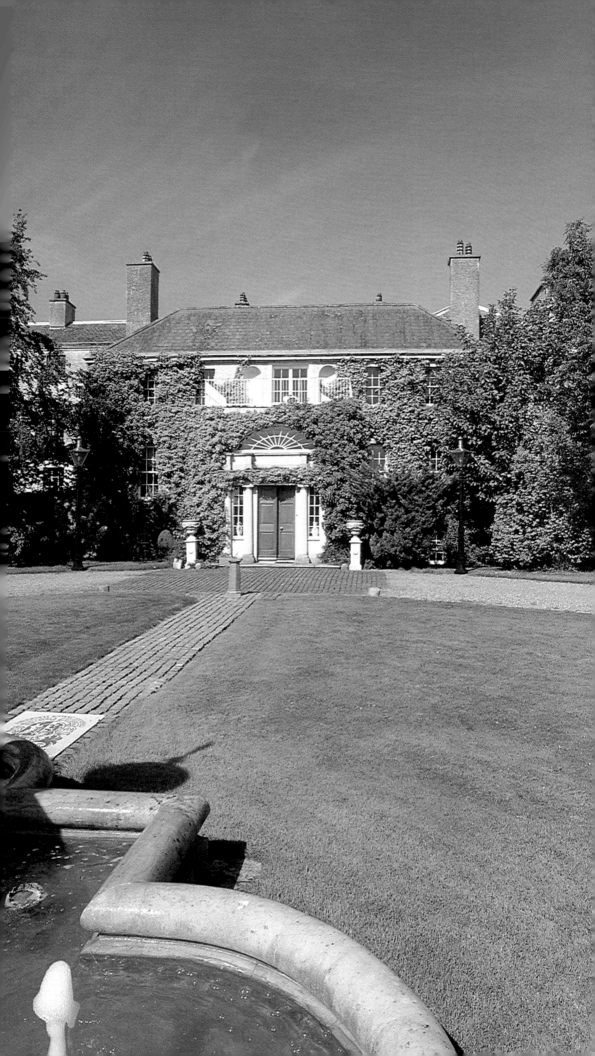

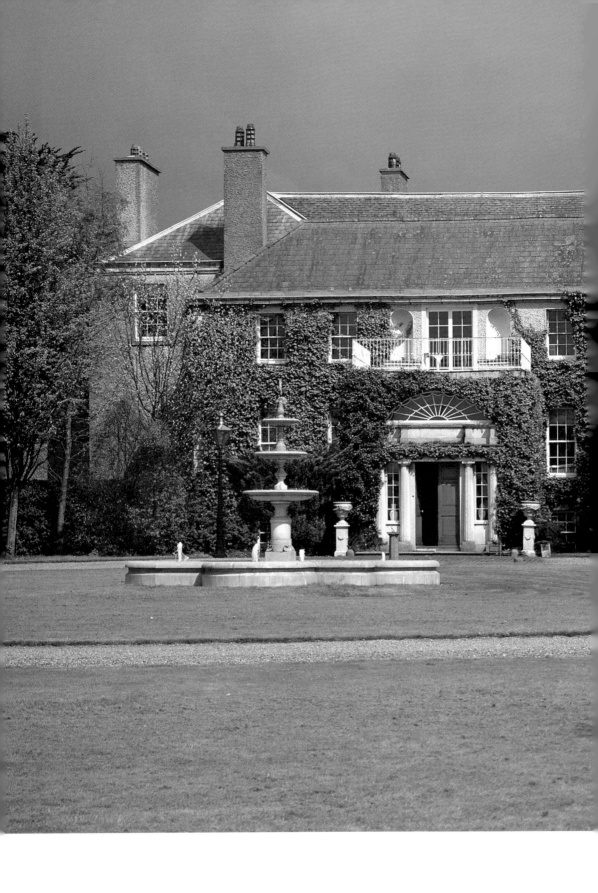

Abbeville is one of the finest Irish examples of domestic Georgian architecture. Here Gandon designed a beautiful, delicately scaled front to impress and welcome the visitor.

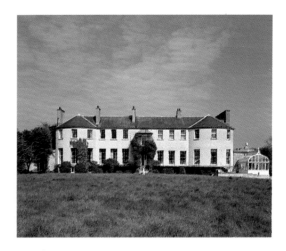

Gandon wrapped new additions around the earlier, probably Jacobean, house and turned the front to the rear. He re-oriented the estate plan and provided a new avenue approaching from the direction of St Doulagh's Church.

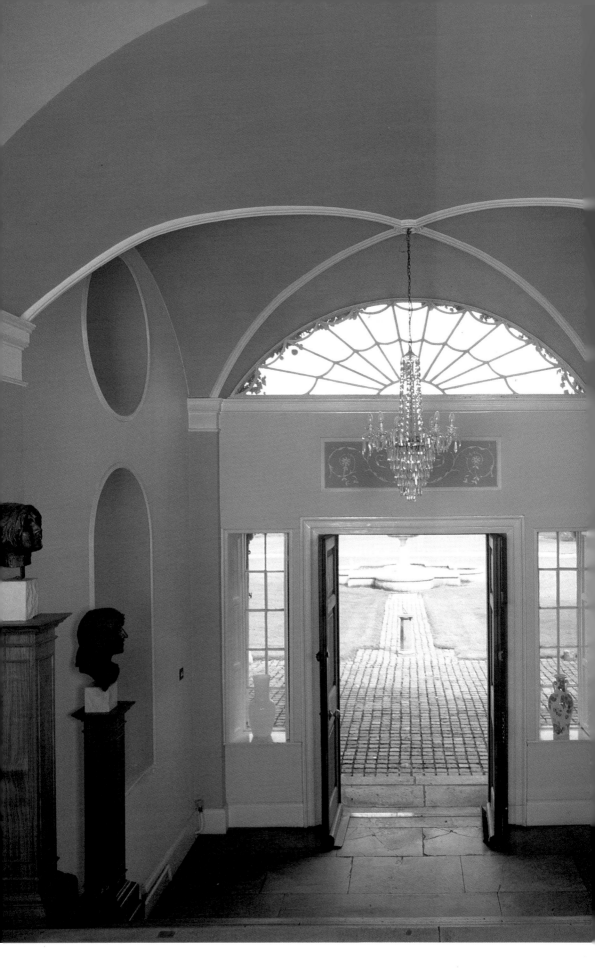

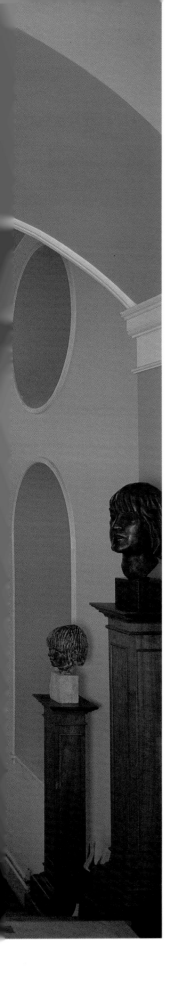

The hallway at Abbeville with a table showing many photographs depicting family scenes and moments from Charles Haughey's long career in Irish political life. On one wall hangs a painting of the Haughey children while on the floor sits one of two porcelain greyhounds.

The imposing vestibule where Gandon elaborately frames the entrance and uses the dynamic vaulting pattern to delight the eye; he adds height to the space by providing the steps inside the front door rather than outside.

Nipper, the custodian of Abbeville, who has met many of the world's leading political figures visiting Kinsealy and has even listened in on a cabinet meeting held at the house.

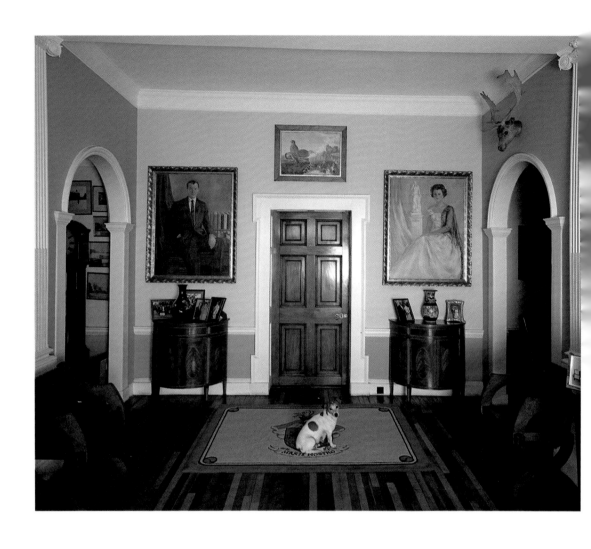

Paintings of Charles and Maureen Haughey hang on either side of the door to the dining-room. Bob
Jobson recalls this big mahogony door and to the right a lobby and 'quiet door' for the
servants to enter the drawing-room.

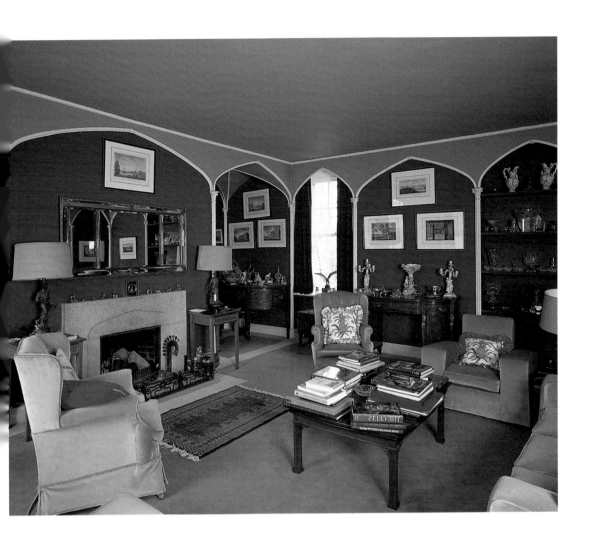

This Gothically inspired space has puzzled architectural hisorians and it has not been firmly dated or

attributed. It may have been designed by Gandon as a kind of stage set, a 'room within a room'. The

Haugheys call it the Malton room as it houses one of the two remaining sets of complete Malton

prints of Dublin painted around the end of the eighteenth century.

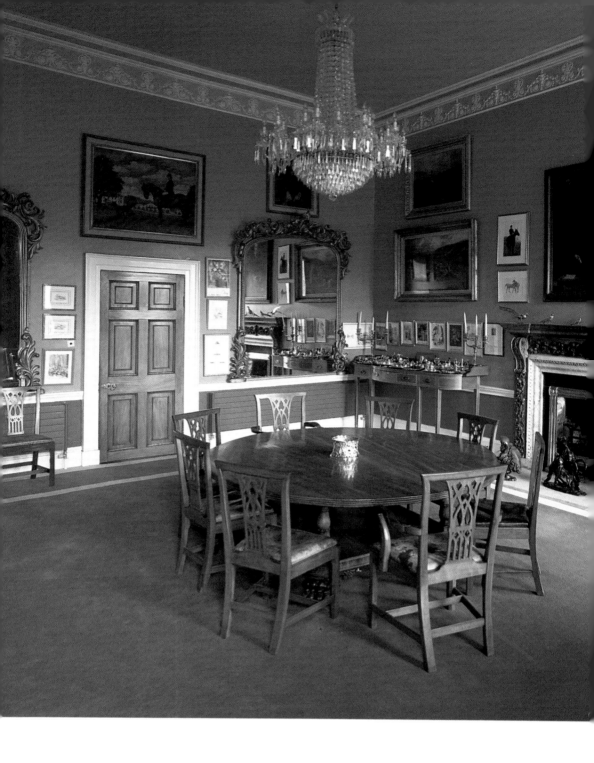

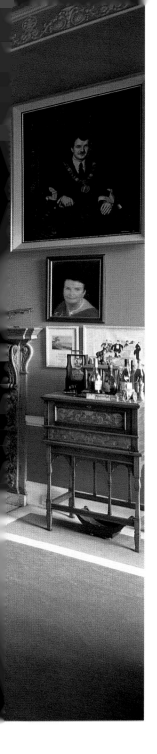

The dining-room, though architecturally austere, is of imposing scale. The nineteenth-century Regency table was brought to the house by the Reynolds family. On the walls hang various portraits of Maureen Haughey, Seán Haughey as Mayor of Dublin, and over the magnificent fireplace with its fine carvings of grapes and vine leaves hangs Haughey's favourite picture of his political hero, Seán Lemass.

The 1780s fireplace with stunning surround in beautifully carved sienna and white marble belongs to one of the principal bedrooms. The elevated rooms overlook the wooded parklands and lake at the back of the house.

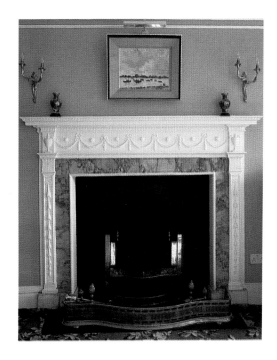

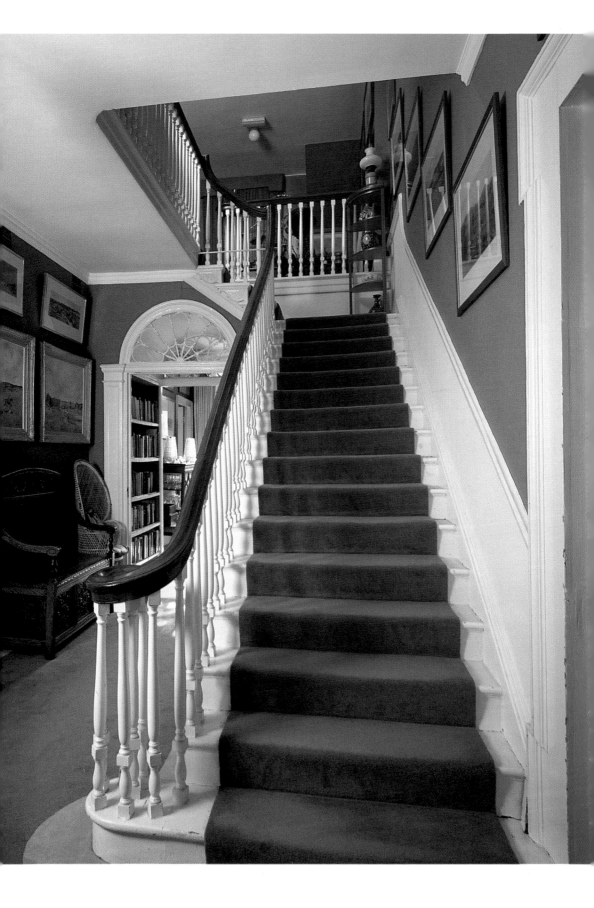

The stairway at Abbeville, dating from the 1730s, leading up to the master bedrooms via the picture gallery. It is a beautiful stairway though uncharacteristically narrow for a house of this size. Throughout the house warrens of stairways and corridors lead up and down to various quarters. 'It was a great place for the children to play hide and seek,' recalls Beatrice Reynolds.

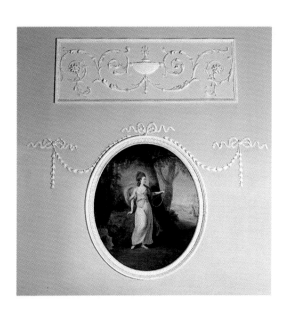

Two of the three Graces painted in the ballroom by Angelica Kauffmann (1741-1807). With these roundels and other elegant plasterwork features on the walls and ceilings, Gandon so scaled and decorated the ballroom that there is no need for hangings or paintings to complete this beautiful space.

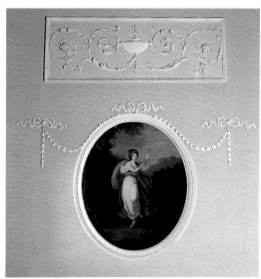

The lush gardens of Abbeville are laden with the scent of roses and the hum of bees. In Victorian times up to eight gardeners took care of the extensive flower beds, vegetable plots and walled-in orchards. In winter, the peaches and apricots were protected from the frost by special heating systems in the garden walls.

Cuchulainn, the great warrior of the Ulster Cycle, standing on the lawns of Abbeville. This twenty-foot tall monument was carved by Joan Smith from an elm tree which fell on the estate. The tradition of using and replacing fallen trees goes back to the time of the Cusacks of Abbeville.

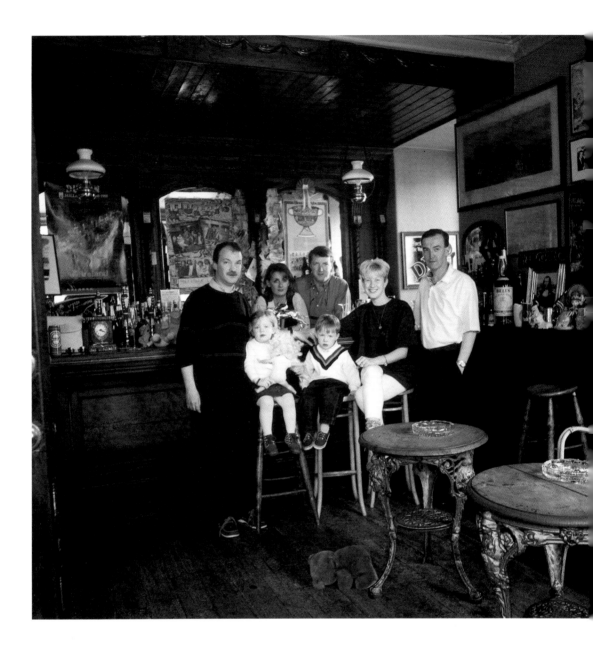

The Haugheys converted one large room into an Irish bar at a time when old-fashioned bar interiors were being torn out of many public houses across the country. This is a very popular room for family and visitors: here the extended family enjoy a Sunday morning drink.

Left to right: (front row) Seán, Caoimhe, Seán Patrick, Laura and Ciarán; (back row) Jackie and Conor.

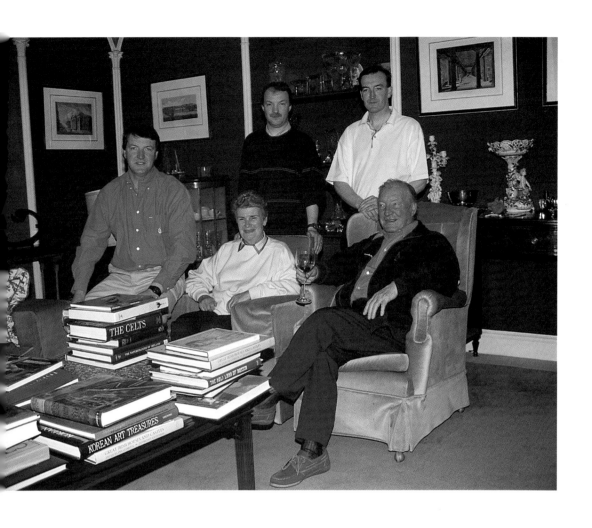

Charles Haughey's three sons have built houses on the estate and Eimear lives in Kildare. Haughey

feels that it is up to them to decide what will become of Abbeville. 'I don't have any pretensions.

The children can do what they like.'

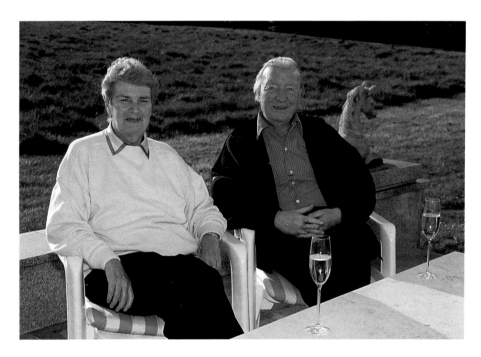

Charles and Maureen enjoying a quiet glass of wine at the back of the house overlooking the lakes and parklands. 'There are five great wines in the world... one of them is Chateau Yquem.'

Eimear Haughey, the only member of the family not to reside on the Abbeville estate.

Bar-stool philosophers Caoimhe and Seán Patrick. Charles and Maureen have given their grandchildren two donkeys, Finn and Ferdia, which are kept for them on the estate.

DRUMS AND DOLLS

Every Christmas, the children of the staff at Abbeville were presented with a gift. Ann McKendry and Joan Kane still remember those rare and slightly daunting occasions on Christmas morning when the children of all the workers on the estate were summoned to the house by Mrs Cusack and brought up to Uncle Piccolo's study. There, each child would shake hands and receive his or her toy; always a doll for the girls and a drum for the boys. 'I still have a picture of one of the dolls which Mrs Cusack gave to me. It was an old Victorian doll. I think military people at that time used to buy them for their wives. This doll was bought at the Wembley exhibition in 1890. She gave me this doll when I was up around the house as usual. It had lots of red and white petticoats and a corset, silk stockings and little leather shoes with buckles on them. It was dressed perfectly. Really beautiful. It had a leather body that was jointed and china arms and face and head of leather with real hair sewn into it. I had it for a long time, but I lost the shoes and cut the hair. I gave it away then to a man who was in antiques. I often wondered what became of it, maybe it's in a dolls museum somewhere. I often thought of having a look for her.'

Ann McKendry was the daughter of the gardener, Jack Curran, whose family lived in the lodge, restored since the big storm. Joan Kane was the daughter of farmhand Bartle Kane, and lived in another cottage close by on the estate. At the time, the entire area of Malahide and Kinsealy seems to have been inhabited by retired majors and generals from the British army. As elsewhere in Dublin, each of the coastal towns had many fine terraces named after lords – such as Carlisle Terrace and Windsor Terrace – all of which provided a great source of employment for the local people. Around the turn of the century almost the entire population of

Kinsealy and Malahide was employed directly or indirectly by the big houses.

'There was always a bob going, and the local people all got a living out of the situation,' recalls Ann McKendry. Apart from the gardeners, farmhands and all the domestic staff who looked after the estate itself, a lot of local people used to earn money from rabbits, pheasants, mushrooms and various other seasonal items which they sold to these houses. Men and women would appear at the back door to display and sell their goods, much of which often came from the land around the big houses in the first place.

Ann McKendry does not remember the interior of Abbeville very well, since they were only ever allowed inside at Christmas, but she knew many of the people who were associated with the house in some way. Danny Fitzgerald, for instance, was one of the unforgettable characters who became an integral part of the strange, revolving economy of Abbeville, selling poached game back to the owners. He was the master poacher and occasionally got a bit of work from Major Cusack to do away with hawks or foxes who threatened the young fowl. For a certain number of foxes the poachers would be repaid in kind and could then claim a bounty of pheasant or woodpigeon for which they had their own market. It was an agreement which appears to have suited all parties at times.

The spirit of mutual favour inevitably broke down however, and the poachers returned to operating outside any agreement. It then fell to Ann McKendry's father, Jack Curran, to catch and report the poachers, something which on occasion ended in tragedy for Ann herself.

'I had a pet jackdaw which had fallen out of a nest and I managed to rear it. My mother had knitted little red socks for it, with its feet out of the bottom. This jackdaw came in and out of the house at will and even came all the way to school in Kinsealy with me and then flew back home. My father had done something on Danny one time so he [Danny] shot my jackdaw and hung it outside on the fence. When I came out to go to school one morning there was my poor jackdaw hanging on the fence. That was the end of our friendship with Danny.'

There was another man who was not fond of Ann McKendry because of

her love of animals. Mr McKenna used to snare rabbits in a field at the front of Abbeville. In the morning, as Ann McKendry got up, she would hear the 'dreadful sound' of rabbits squealing, 'very like a human voice.' She would run down to the field, liberate the rabbits and take the copper wire snares away.

Snaring and hunting was very a popular pastime with the locals around Abbeville. In these pre-television times, a Sunday afternoon would be given over to a football match or a hunt. Young men accompanied by six or seven dogs would go after foxes or hare. The Fingal Harriers had, and still have, permission to go through Abbeville twice a year, and a legendary stag is once known to have evaded every hunter in Malahide by swimming across the lake to safety on the island.

As well as water, the lake at Abbeville provided a great local source of food. Though it was effectively man-made, the lake was connected to the sea by a river through which many eels entered; huge eels which were cooked alive and eaten with aspic or jelly. At times too, they would get stuck in the generator and men would have to go up and free them. 'The electricity was generated by carbines down near the lake. There was a dam there to trawl the water correctly. It was nearly half underground with all these big glass bottles full of acid for the carbines.'

Ann McKendry remembers her father as being very happy in Abbeville. After the sale of Abbeville he continued to work at the nearby bungalow garden of Major Cusack's sister, Violet, in Yellow Walls, growing special plants to attract birds. He maintained many other gardens too, as well as keeping his own cottage garden with lots of rare plants from the big house. It was a tradition which Ann McKendry, who has a large, immaculately kept cottage garden in her Malahide home, inherited from her father. Her sister, Maureen, runs a garden centre with her husband and Ann's son, Alan, has recently qualified as a horticulturalist. Peter Walsh, the head gardener in Abbeville at the time, also passed on his interest in horticulture to his descendants and his great-grandnephews; Christopher Heavey works in Teagasc, the Kinsealy Research Centre and Timothy O'Mahony is a student at the Botanic Gardens, Glasnevin.

Ann had never been back to Abbeville until Daffodil Day of 1995 when Charles Haughey opened the gates to the public for a fundraising event

for the Irish Cancer Society. 'I was delighted to come back again. The cottage where I lived as a child is now used by the guards for security and I asked if I could go inside. It was a tiny cottage but we never felt squashed. There was a small porch in the front and just two rooms, a living-room with a grate and a bedroom in which we all slept, myself, my sister, my mother and my father. I was amazed when I saw it again because it seemed so small and I couldn't imagine where the families that visited us on Sunday afternoon would fit.'

Things had changed dramatically at Abbeville, however, and as a keen gardener she feels a certain nostalgia for the fussy and meticulous gardening traditions of the Victorian era. 'I was disappointed that the gardens had gone over the years and I would dearly love to see them restored.' Having visited many gardens of great houses in England, she feels that the same interest had never been encouraged here. 'My son has studied horticulture, landscaping and design in England. There are some absolutely magnificent gardens there attached to the big houses. They are great places for relaxation and also a wonderful way to learn about how our ancestors lived.'

Among her father's duties under the Cusacks was the responsibility for storing the fruit from Abbeville's spectacular orchards. There were lofts with wooden racks on which the fruit would be stored in the dark so that the house had a harvest of apples and pears right throughout the winter. All the fruit had to be turned by hand each week or fortnight. 'The ripe ones were brought to the table and the bad ones thrown out. There was no question of going out and buying anything like that. It was all produced on the farm. Every kind of fruit you could think of.' The grapes came from the greenhouse that, at four hundred feet long in the 1830s, was considered Ireland's largest at the time. Abbeville wine was made from these vines.'

Jack Curran was also given the charge of the vineries when he took over from Peter Walsh as head gardener of Abbeville. At the back of Cintra, a house near the entrance gates to Abbeville and formerly part of the estate, there was a field known as the Brewery Field where they once grew their own hops. Back in 1821 they made their own beer here and sold it in a hostelry named Reilly's of Copper Bush. Rumour had it that a secret

tunnel went from Cintra to the drinking establishment, which was owned by the inhabitants of Cintra.

The vegetable gardens were surrounded by thick walls, fifteen feet high. Each wall was selected for a particular fruit — figs, peaches, apricots, pears or apples — depending on how much heat it received from the sun and from the garden heating system. Sensitive fruits such as peaches and apricots were heated by a special chimney at the centre of the wall. Hotbeds were built for young plants, with a glass covering and manure which created heat. Flower seeds were collected from which new plants would be grown. Every vegetable and flower was grown from its own seed, recalls Anne McKendry. The surrounding cottages on the estate were given all their own vegetables and fruit from the main house. Nothing was ever bought in, and the flower garden had a huge and beautiful herbaceous border on the left as you went in.

'The Cusacks were very big into the gardens and spent an awful lot of time in them. Oh yes, they were always there pottering around, walking and looking and telling the men what to do. They used the gardens a lot to sit in. The older ladies sat out and did their needlework. There were lots of roses climbing over the pergola, which ran all down the centre of the garden by the fountain. Lovely old-fashioned, beautifully scented peony roses and delphiniums. Around all the beds there were box hedges in squares which had to be trimmed by hand. It was amazing the amount of work people did in those days.'

The lawns were mowed once a week and edged to perfection. The mowing machine was pulled by an old brown donkey named Neddy. The green in front of Abbeville stretched all the way along the avenue down to the gate lodge, looking like a 'bowling green' at all times. There were further lawns going down towards the fountain and at the back of the house; beautiful lawns that followed the avenue walk through Greenwood along the near side of the lake.

Her father also tended the beehives and provided honey for the house. Thanks to the rock gardens, stocked with delicate imported alpines and primroses, the Abbeville honey was very special. A large area was planted with bamboo canes which were tended and cut for use for the vines and chrysanthemums. 'Everything was home produced, they were totally self-

sufficient. The animals on the farm were mainly cattle and working horses. It was not for beef but for the dairy, and I don't remember big herds of cattle.'

Up to the time that the house was sold, the Cusacks kept a beautiful old carriage in the coach house. It went out of use, however, when they bought a 'very old-fashioned' motor car. Long before Ann McKendry was born, her father took driving lessons to add the duty of chauffeur to his gardening duties.

Her older sister Maureen remembers an ambulance coming up to Abbeville on one occasion when the cook met with a small accident. 'The cook's name was Mary and she liked a sup of wine. I suppose she decided to put her legs up at the stove after a long day. So she sat with her feet in the oven door and fell asleep, burning the soles of her feet, and had to be taken away to hospital. It was a motorised ambulance and was the cause of great excitement altogether.'

The thrashing days were also a cause for great excitement. Ann and Joan loved to watch the steam-operated engine coming up the avenue once a year. 'Even when the mill was left there at night before the thrashing next day, we would run up to have a look at it,' recalls Joan. 'It was covered with tarpaulin, even the ricks of corn were covered. We were kept at a distance when the thrashing was going on. Watching all the chaff and the dust flying out of the wheat. It was lovely. And when it was leaving, going down the avenue, we'd watch again. Sometimes we'd know which farm it was going to and we'd watch it out of sight.'

They used to love riding on the back of haycocks as they were winched up into the barn. Whenever they were cutting corn the cook would send out containers of homemade lemonade made with 'lemony coloured sugary crystals. They came down with big cans or buckets for the men. It was beautiful, so lemony, great for quenching the thirst during the thrashing. They would also bring down great cans of buttermilk but Ann and I didn't like that so much. The men in the field would love it, over their potatoes in the evening too.'

Joan remembers her Uncle John being responsible for milking the cows. 'We'd be tormenting the heart out of him. We'd be shouting and pulling

the cows' tails and they would hit him in the face while he was milking. We'd be peeping in the door and he'd wait till we got close enough, then he'd suddenly turn around and squirt the milk at us and we'd run screaming. Then, of course, we only ended up tormenting him twice as much.'

When the horses were being brought up to graze in the top field, the young girls would go up there with them and were sometimes lifted up on the bare backs of big working horses, terrified because the ground seemed so far away. On other occasions, they can remember going out on the lake in boats. The lake was cleaned with a chain spanning between two boats, using scythes to get rid of the weeds. Joan's father made a box trailer for the back of the bicycle and would take the three children off to Malahide Strand on a Sunday. Those were the days too, when they relied on oil-lamps and candles, so that Joan and Ann recall being terrified walking along the dark avenue at night.

During the war, Joan remembers hearing the sirens going off at Dublin Airport, upon which the whole family would clamber in under the bed. One particular night, after they heard a terrific bang, her father went to investigate with a candle and found that a piece of shell had come through the scullery roof leaving a hole in the floor; it was the night of the North Strand bombing. 'All up the avenue the next day we found pieces of shrapnel or shell and we would gather them up and I remember my mother was terrified of them, she didn't want us to bring them into the house,' recalls Ann.

Looking back, Ann feels that people were very humble and perhaps even servile in front of the nobility. She herself felt none of this humility and got on very well with Major Cusack. 'I never felt intimidated, but I can remember how the older people, like my father for instance, would tip his hat whenever he would meet the Major. He would give a little half-bow or genuflect whenever he met Mrs Cusack. As a child that seemed strange to me. When I grew up, I resented that sort of subservience. It was always Sir or Madam. I was probably more cheeky; I never really drew back. I was quite friendly with Major Cusack. I would talk to him and accompany him on his walks around the estate. I remember him asking my mother why my sister always looked so clean while I always looked so dirty. I

always hung around the house or the yard with the men and I never felt that I shouldn't be there.'

Joan's parents, on the other hand, would always tell them that they should have respect for certain people. Perhaps they were a bit in awe of Major Cusack, she feels, even though her father was a nationalist. The fact that he was working for a member of the British army did not worry him, however. He was glad to have a job, and almost all the big houses in Malahide were ex-British army people. 'You just got on with your life,' says Joan. 'It was a matter of needing a job and a home. At the same time many of those in the big houses were quite good to us during the war years. We always got timber, for instance. The Cusacks would cut trees for everybody in the winter, not just for people on the estate but for people around Kinsealy too. They provided them with vegetables, butter and milk.'

Life became hard for Joan's family when the estate was finally sold in the 1940s. Initially, they had nowhere to go when the Cusacks left, and the family were all split up. She went to live with an aunt and uncle in Monkstown while the rest of the family lived in Kinsealy Lane and Raheny before her father eventually got a job on the neighbouring estate at Emsworth. Some time later, Joan's father got a permanent and pensionable job with the County Council.

Over the years, Major Cusack, like many of the previous occupants of Abbeville, travelled a lot and brought back hundreds of artefacts from the British colonies. Out over the coach houses Ann remembers rooms and rooms of butterflies, all in cases and cabinets. There were drawers full of birds' eggs which came from all kinds of foreign places. Everything was labelled. Some were kept in jars in cotton wool, insects preserved in liquid in bottles standing neatly arranged in the cabinets. As children they got the impression that everything was still alive if they picked up the jars and moved them around. While the dog museum was inside the 'big house', there were plenty of other stuffed animals over the coach house, everything from monkeys and bears to all sorts of crocodiles and beautiful stuffed birds.

Most of these were thrown out when Abbeville was sold. It seemed that when the estate was passed on to the next owner, a whole way of life was

sent out to the bonfire. Nobody had any need for these collections any more. Ann remembers how her father spent weeks and weeks burning boxes of papers and photographs for Major Cusack, all their belongings which had accumulated over the hundred years that the Cusacks dwelt in Abbeville. It was during this final clearing that the priceless Gandon elevations of the house were destroyed, along with leather-bound books and complete sets and volumes of *The Times*. Occasionally, her father arrived home with leather-bound books or dictionaries which were meant for burning. Everything was sentenced to the fire: books, documents, personal belongings and thousands of photographs – whole lifetimes of memories disappeared in the flames. Ann's family adopted some of the stuffed animals and took them into their houses.

'We got a stuffed monkey in a cage. We also got two stuffed bear cubs which we used for years as hat stands, huge things. We got all these birds as well, lovely birds in glass domed cages. They had no value at all and when they were worn out or were broken or we had no room for them any more, we got rid of them.'

T H E P O A C H E R S

He was the true Lord of Abbeville. He was the eight-year-old master of all he surveyed, the young lad from the cottages who robbed the orchards, raided the greenhouses and collected the firewood after the storms. He was the *Páistín Fionn*, the boy with the blonde hair who knew every inch of the grounds and crept silently, out of sight, along the Victorian box hedges. He was called the troglodyte; the boy who was hunted down tirelessly by the gardeners; the true, untitled heir to the estate of Abbeville, who sat on top of the walls stretching out towards the pear trees with a cane and a tin can attached to the end; the young Irish nobleman who knew the taste of all the strange fruits – the pears, apricots, tomatoes, figs and furry peaches.

Jack Moore grew up a short distance away from Abbeville at the Cross of Kinsealy. His father was a railway worker and the family lived in a small cottage no more than two fields away from the grounds of the estate. He spent his whole childhood climbing walls and trees in search of Major Cusack's exotic harvest. 'The first peach I tasted in my life was here at Abbeville,' said Jack on his first ever return visit to the grounds, nearly fifty years later.

'They tickled my lips. They had hairy skin, I remember that. I can see myself there like some monkey, tasting a peach and hurriedly looking around to see if anyone was coming. Oh, peaches were lovely. I never brought any home because my parents wouldn't subscribe to that. They were loving and kind but they wouldn't have any of that carry on. I never looked on it as robbing. Even when there was nothing in the garden I'd be in here for the fun, maybe for the thrill of the chase.

'The place had me like a magnet. It was nearly the undoing of me. I remember my first tomato too, I was so attracted to the red. I knew they were growing them to be eaten, but I spit it out on the floor of the greenhouse, seeds all over the place. I hated the cucumbers. Holy God, the first time I tasted them I thought I'd never get my face straight again. I took a bite out of this thing and the hinges, you know the bits that are here under your jaw, they locked and that frightened me. Sparrow grass (asparagus) tasted like snots, they were sticky and green. Artichokes looked like a potato with warts. I thought they were thistles and didn't go near them for a long time either. I crept in, unbeknownst. There was a lot of fun in it. I never broke anything and I always went alone. The only time I ever brought someone with me he ate everything – so I never brought anyone with me again. I was about eight when I started.'

Jack Moore's entry point into the Abbeville estate was through the cats' and dogs' graveyard where the end of the wall was fortified by a protective wire. There he made his way in under the wall by digging a hole and crawling through, making sure to cover it up again every time he left. He recalls rooting around under the ivy and finding the gravestones bearing the words 'to my beloved' and first thinking it was a human graveyard. This was his approach to the great house, crawling along the box hedges, out of sight of the gardener who would be working obliviously among the beds. From a vantage point on the top of the garden wall, he would take a long bamboo cane to which he had tied a can with binder twine, all found on the estate, then take another cane and deftly tip a ripe pear into the can. The first time he did this he remembers the gardener looking up suspiciously at the sound of the pear hitting the bottom of the can. So he modified his device by putting a small sod in the bottom to deaden the sound, after which the gardener, Ann McKendry's father Jack Curran, was left mystified by the disappearance of the fruit without a single footprint left behind in evidence on the beds beneath.

After school Jack Moore would throw the books in at the door, change out of his school clothes and head straight up to Abbeville, stopping briefly for a 'cut of bread and some shell cocoa.' This was a blue tinted, bitter tasting drink made from cocoa shells which are now used only for mulch but which, during the war years, constituted a valuable source of nourishment. Little did Jack Moore's parents know that their son's

vitamin requirements were more than satisfied by the Abbeville orchards. Jack Moore had some rivals, however. The 'Baskin lads' from the Baskin cottages some distance away also had a taste for fruit. 'I felt this was my place in a sense and the Baskin lads who would come across from the far side were encroaching on my territory.' For a bit of diversion, he would go up to Greenwood, a house which was part of the Abbeville estate, and try and get the Baskin lads into trouble.

'There was a huge, old fig tree there, and after I got my dowry of apples out of the garden I'd sit on the wall behind the tree and wait for the Baskin lads. You'd hear them coming across the hills like Geronimo and a herd of Indians. I'd be waiting for them, and as soon as they were well laden with apples and their jumpers all tied under them, I'd call the gardener, Mr Reid or the Wacker Reid as he was affectionately known. I'd give this John Wayne cavalry cry – the kind you heard in the pictures – and all their heads would come up like prarie dogs. Then down the Wacker would come at full tilt and they were caught. The strange thing I always thought was that these lads never threw out the apples when they were caught. I always hid my apples away on the wall to lighten the load if I needed to get out fast and then I could come back for them later.' Next day in school, Jack Moore would get out of a certain beating from the Baskin lads by letting them copy his maths.

Ann McKendry remembers how her father had to chase the invaders out of Abbeville and how he once found a schoolbag left behind in haste by one of the Baskin lads. She would also come in for punishment from the boys if they had been caught. 'They used to beat the lard out of Maureen and myself, so I began to carry an elder stick. Many of them would be afraid of this stick since it was said that if you got a belt from an elder you'd never grow again. If it was true, wouldn't there be an awful lot more small people around?' Though Jack Moore and Ann McKendry are great friends now, he was frequently chased through the estate at high speed by her father, and even recalls examining himself on various occasions to see if he had stopped growing.

He recalls playing in the ice house at the back of Greenwood, the neighbouring house to Abbeville, when Colonel Twigg came out of the house shouting: 'Bloody troglodytes are here again.' He had been called

everything from a cur to a whelp, so this stuck in his mind. It was only later on that he worked out that Colonel Twigg was referring to him as a cave dweller emerging from the dome shaped ice house.

Another one of his tricks was to open up the sluice gates on the lake. In order to work the generator, the head gardener Jack Curran would wait till the lake was full and then send the water through the turbine to create the electricity for the house. Jack Moore would release the water in the other direction, however, sending it cascading over the waterfall and 'breaking the poor man's heart.'

On summer evenings he would fish there with a thread and a bent pin. 'On certain days the black thread would work better for the fishing, we'd put a bit of dough on the end, but I didn't like the eels, they would mess up the line. It was a bent pin and a stout bottle cork. Roach were too bony but you could eat them all the same.'

In winter, during the years of the war, many of the local boys would find themselves in Abbeville looking for fuel. 'We would be looking for kindling to light the fires and we'd always be hoping that it was windy, because the wind would blow them down. If we didn't get sticks we'd riddle the ashes from the big house at the end of the garden wall.' At the age of eleven he went up with his mother's sieve and an old pram to bring back the sticks. There was a great walnut tree on the estate, and Jack recalls the fact that the green skin of the walnuts turned his fingers brown, covering up for the fact that he had already started smoking Ruddles Ten Toe cigarettes.

Even though Major Cusack frequently cut down a tree and distributed the firewood among the local people, the boys in the area would still exploit the woods and cut down branches. 'Some lads though didn't know how to cut sticks. They would cut anything. You'd hear the sticks cracking and you'd say: Christ they're at it again. Then there would be a raid on and they would look under the beds in all the cottages for stolen wood. You can still see the scars of their handiwork on the trees.

'We were cold, but disfiguring a tree would never do. If you got a handy bough of a tree, that wouldn't disfigure anything, you'd give it a nick. They never learned to knock down a bough without it cracking and

tearing a big strip down the side of the tree, exposing the white. We would give it a nick underneath the bough, then cut the other one on the top end and pray to God that the wind would come soon and turn it into a windfall. You'd always bring up a wet sod and give the white section a rub down with it so that she married in the same colour, and they never copped that one.'

Fires were essential not only for cooking but also as a central feature of the Irish home. There was no coal at the time and without the firewood from Abbeville many families would have gone hungry and cold. Consequently he can understand the Baskin lads indiscriminately 'whaling into evergreens, oaks and beeches.'

The winter of 1947 was particularly bad, and the lake froze over for about six weeks. Having exhausted the lands around Abbeville of spare kindling twigs, the locals then found a bountiful supply of sticks on the lake island that nobody had been able to get to before. By walking across the frozen ice they found a real harvest that year.

'The poor old Major nearly went mad. I remember him coming out onto the veranda looking like somebody out of the pictures. Wearing a silk dressing gown and tassels like you would tie up curtains with, he started shouting at us. 'Get off, get off! It'll go! Bloody, bloody hell!' That was the nearest we ever got to him and God knows we provoked him enough. Obviously he was thinking of our safety. The Baskin lads were all there on the ice.'

Jack Moore recalls another occasion when he was discreetly cutting some twigs from a laurel tree near the cats' and dogs' graveyard. He used to pray that the gardener would never oil the gate so that the tiny squeak would act as a warning. On this occasion, however he was chased by Major Cusack's nephew, Bob Jobson, who was very tall and had long legs. 'I can tell you they should have entered us in the Olympics. I'm not codding you. He could certainly shift with his woeful longs legs. I made my legs work overtime that day.'

Bob Jobson, on the other hand, recalls the damage to the trees from a different angle. Huge beechwoods were butchered by degrees by 'the Baskin young fellows.' Hundreds of years of growth was hacked away in a

space of two years. He would go patrolling the woods himself and on several occasions had the locals prosecuted in Swords court for cutting timber illegally. He would inform the court that they had promised their families all the wood they needed within reason. But Justice Reddin would do little more than fine them five shillings and then tell Bob Jobson to give them back their confiscated saws.

Jack Moore agrees that there was terrible destruction caused to the Abbeville trees during the war years. He himself drew the line at ornamental trees and never touched a birch or walnut. He had a great respect for trees and sometimes renamed them, like the laurel which he called the 'benediction tree' because its wood, when burning, smelled like the incense in the thurible. At school they sang the Irish language song which commemorated the Flight of the Earls and the destruction of the ancient Irish forests which were said to have been cut down and used for the British navy. 'Cad a dhéanfaimíd feasta gan adhmaid…' (What will we do now without wood…)

In the main, he feels that the Cusacks were a 'very decent family. Of course you've got to understand the pecking order, a lot of which still exists. You went to the back door if you wanted something. I never felt servile though, never. I remember the Cusacks in the 1940s as good people so I've no reason to believe they were any different during the famine.'

There were good and bad landlords, as far as Jack Moore is concerned, but the landlords around Kinsealy and Malahide had a good reputation for helping the local people in later years, even if their agents pursued their tenants more rigidly. Lord Talbot de Malahide, the Hones of St Doulagh's, the Jamesons of Carrick Hill and the Jamesons of Seamount were all seen to be very fair-minded, giving the local people a regular sack of flour and milk during the war years. In a curious twist of irony Lord Talbot also employed the old IRA to blow up stumps of trees. It is known too, that the big houses in the area received some protection from the local people too during the War of Independence.
'I remember my mother coming down from Greenwood on very cold days. Her hands would be cut from the work. She'd put her hands on your face; the two of them, one each side and she kissed me. Her hands were rough

and bleeding from the washing soda. It was then that I used to think how unfair things were. That was the only time I remember crying, when my mother's hands were bleeding. As a boy it made me angry too. It was the last of the ascendancy times and they felt they had a right to be here.

'Personally I'm very glad to see the man himself, Charlie, here in Abbeville. The place could have been covered over in concrete. It's good to know that he is retaining it and carrying on with things; the horses and the deer. And I suppose in a way we were lucky. I don't know what the Cusacks thought of us. As a child I wasn't aware of the word imbalance, but I knew something wasn't right.'

In fact, Jack Moore feels that a certain insensitivity must have prevailed later on which allowed some of these historic houses and landmarks to disappear. He recalls a bulldozer with a giant steel hawser knocking down the ancient windmill on the Abbeville estate. At the time, the workers explained that the windmill was deemed to be dangerous, and he replied that it had been dangerous for centuries and nobody had ever been troubled by it. He also laments that Millview House, home of the famous John Kettle who fought for tenants' rights, was also pulled down in the 1970s.

It was well over forty years since Jack Moore had set foot on the Abbeville estate. He remembered an old bell which has since disappeared but which was used in the old days to call people to work at eight in the morning, at twelve noon and again at six in the evening to mark the end of the working day. At the back avenue into the stable yard, he recalls coming to get his legitimate ration of apples at Halloween, 'anything I'd left in the garden, that was.' He recalled the lovely smell of apples in the barn and how it was the gardener Jack Curran who would give the local children their apples. He also recalled a bad stinging he once got from the Russian rhubarb, or hogweed, which was originally brought to Ireland during the Victorian era as an ornamental plant, but which has now become a menace and spread steadily along the waterways of the country.

Once a year local people would come up to the fields of the estate to collect chaff for their calico mattresses. Everyone would be there filling up sacks with chaff, hoping they would not contain any thistles. The mattress would start off at a great height and settle down after a few

nights. There seemed to be countless memories like these which would stop Jack Moore suddenly along the path.

As we finished our walk through the gardens and turned towards the house, he remembered how he often had to wear a cap to cover his blonde hair, particularly when he was in view of the house. Though, as a child, he may have been camouflaged among some of the tall, exotic plants in the gardens, there was always a danger of being seen from the many windows which must have appeared to stare out across the parklands like countless vigilant eyes. Now the house of Abbeville stood before him again like a daunting and mysterious edifice at the end of the avenue. He had never been inside. Indeed, he had never allowed himself to venture this far before, and as he moved cautiously towards the main door he tried to guess what wood it was made from.

'Is it a yew door, I wonder? Could I go up and look at it? I've never been up this close to the house before. It feels quite strange. Am I allowed?' he asked as he stepped up to touch the door with his hand.

THE GARDENS

'We are not very formal here,' says Charles Haughey, speaking as much to describe the Irish race as the shape and design of the Abbeville estate. What he is saying in fact is that he finds the Victorian gardening aesthetics of meticulous box hedges, ornamental shrubs and labour-intensive flower displays too fussy for his liking. Though the lawns and gardens of Abbeville are always beautifully kept and well stocked with roses, climbers, herbaceous borders, shrubs and fruit trees, there is a reluctance to return to the meretricious splendour of the Victorian era. He has maintained many of the best features of the gardens and parklands without falling victim to the embroidered horticulture of the last century.

Because of Ireland's turbulent social and political history, the traditional view is that going right back to the Viking invasions, Irish gardening cannot claim any significant aesthetic achievement until the Victorian times. Even though Irish gardening is said by some to have held its own, it is clear from the Céide Fields in County Mayo to the subsistence farms of the eighteenth and nineteenth centuries, that land in Ireland was undoubtedly devoted more generally to crop raising and other functional uses. On the premise that ornamental gardening thrives in times of prosperity and peace, Irish gardening saw a brief flowering in the period of the early abbeys and monasteries, but really only came to a peak in Victorian times. A period of relative stability after the Act of Union in 1800 allowed big houses to design and maintain some of the gardening qualities which already existed in Britain and even more so on the continent.

Abbeville's gardens were laid out with all the precision of Georgian values.

Parklands were designed with screens of oak and elm to hide the more utilitarian farms. Like the Gandon interiors which allowed the eye to travel through archways and passages into connecting rooms, the estate was designed with a certain sense of aesthetic deception, giving partial views onto lands beyond. Mounds, lakes, paths and woods were laid out in such a way that they had the effect of an optical illusion, creating an undulating, mannered landscape which suggested a natural and infinite domain. Straight lines were displeasing to the eye, and so avenues meandered along in a serpentine fashion with no great deference to the time it took to get to the house. It was an era, after all, which stressed leisure and aesthetics in combination with the functional.

Standing at the front entrance to Abbeville, gardening historian Paddy Bowe drew attention to the fact that Georgians wanted everything to look natural. Apart from the house itself, every other man-made object was concealed from the avenue and house by trees and shrubs. 'The approach to the house at that time was always curving, for the simple reason that from a carriage coming up a straight avenue, only the coachman got the view. All the passengers saw from the side windows were the trees, so they laid out a serpentine approach instead.'

Walls were mostly south-facing to protect fruit from the frost. Net canopies, which could be pulled down to cover the trees, were built in under the wall caps. Greenhouses and hotbeds were designed to produce exotic vegetables, which later in Victorian times were believed to be the mark of nobility and lead to a superior intelligence, while the humble and less noble potato was said to make people dull-witted. Vegetables such as leeks and turnips which were more difficult to grow were deemed better than the easily cultivated potato, a theory which was reinforced by the Punch caricatures of the time.

But above all else, the Victorians found a century in which they could plant all kinds of ostentatious displays of flowers and shrubs which they had brought home from far away places around the world. Knowledge and experience of fine, exotic horticulture was also seen as a mark of nobility. Abbeville had a particularly fine gardening reputation, which even came to the attention of Queen Victoria, who would send for bulbs for her own gardens. This tradition came to its peak during the Cusacks' tenure when

Abbeville employed three out of eight gardeners to tend to the flowers alone. And Ralph Cusack, the nephew of Major Cusack who was the last in the line at Abbeville became famous for his witty seed catalogues with entries such as the pink *Cyclamen libanoticum* from Lebanon, the rare Crimean snowdrop *Galanthus plicatus*, the *Iris backeriana* from Armenia in former Persia, or the lilac-coloured *Anemone biflora* from Kashmir.

Ordnance Survey maps drawn every twenty or thirty years record these changes in attitude. 'My impression is that the avenue in current use is actually the service entrance. Because it's straight, and leads to the walled garden, I would say it was used to bring up manure from the farm land and all that sort of thing.' The main avenue would have come up from the main Kinsealy road, not far from Kinsealy Church.

The parklands of Abbeville are a good example of the undulating grasslands which were so popular in the eighteenth century. The ideal of beauty and utility was to look out on parkland that was graced by cattle and so was also generating an income. In the nineteenth century they began to plant exotic trees such as the Lebanon cedar and conifers. The important thing about a country house was that it should sit on grass. Paddy Bowe feels that the current vogue of putting gravel right to the base goes against the Victorian thinking, and often makes big houses look more like schoolyards. In Abbeville, Charles Haughey has maintained that soft effect by framing the house with trees and lawns.

The fountain on the cricket oval at the front of the house originally came from the lower part of the garden. Soon after the Haugheys moved in, this white marble fountain was found under a mass of brambles and weeds. Architect Austin Dunphy discovered the top section lying on its side in the lower garden and restored it to its original beauty. 'Later, Charles Haughey rang me and asked me to move it around to the front of the house. The lower dish was badly cracked and the Earley Brothers of Camden Street made a new sandstone base which came from Abbeville in France. You can see how perfectly it fits in.'

The fountain is a three-tiered Victorian piece in white marble, with water falling into a baroque-style basin. The main decorative motif is an evergreen acanthus leaf which was used a great deal in classical Greek sculpture. The new section was designed with a shell motif which was felt

to be appropriate because of the water connection. Flat on the ground at the base of the fountain is the Haughey coat of arms depicting a lion and stag respecting each other and bearing the Latin words: *Marte Nostro* (By our own efforts).

There are two walled gardens at Abbeville. The original garden, situated behind the stables, served as a vegetable garden and orchard providing the house and staff with food. The other garden, situated on the southern side of the house, was mainly devoted to flowers and exotic fruit. The south-facing walls were clad in brick because, unlike stone, it retained and radiated heat like a storage heater. If frost or cold weather was expected they would lower the awnings or light the specially designed fireplaces in the walls, just to get the peaches, or other fruit, over the cold snap.

At one point the enormous Victorian vegetable garden became no longer necessary. When tenant farmers availed of the Land Acts to buy their own property and became less dependent on the estate by growing their own vegetables, the gardens were gradually given over to more decorative purposes with many exotic varieties of plants and shrubs. The elegant wisteria growing on the west wall is believed to have existed since the time of Beresford, and now has a very large graft knuckle and a heavy stem. The animal graveyard at the back of the original vegetable garden is still in existence, but Charles Haughey shows no interest in it; in fact he finds it a little obscene.

At the end of the nineteenth century the construction of rock-gardens and the culture of alpine flowers became widespread in Ireland. The first rockeries were located in shadowy places, mostly for growing ferns. Later on, the Victorian gardener began to experiment with imported, sun-loving alpines. The rockery in the Abbeville garden is thought to have been erected around the time that the Victorian garden was designed. It is a rare and interesting period piece, in keeping with the Victorian passion for procuring unusual rocks, for which they would have paid quite a sum at the time. The selection of rocks is traditionally a Chinese pastime where gardens are based on curiously shaped rocks.
The Abbeville rockery, which extends from the beehives at the top of the walled garden down past a large old magnolia tree towards a lower gravel path, contains rocks with reddish stones as well as other more weather-

worn rocks with many interesting indentations. All of these stones would have been individually selected for their sculptural or textural value, unlike the rockery in a contemporary garden which would tend to have uniform stones. The stones at Abbeville include red sandstone conglomerates, quartz and limestone as well as chert in the archway in the centre of the rockery. The depressions in some stones are due to weathering over a long period of time or because of the presence of boring molluscs. According to geologists Dr Andrew Sleeman and C Barry Long, the rocks probably came from different parts of Ireland; from the west, or in the case of the quartzite, from nearby Howth, or from the Sugarloaf Mountain in County Wicklow.

'All the bored stones which we see here with the honeycomb effect are quite interesting. Gardeners can pay a lot for limestone like this which has been under water and which will look very effective in a rockery. In the west of Ireland you can see how people have deliberately placed unusual stones at eye-level in some of the walls. However, this Victorian trend of collecting rare rocks might ultimately endanger precious areas such as the Burren,' says Dr Sleeman.

Dermot Gavin, a garden design consultant who does work at Abbeville, feels that the rockery interferes with the overall look of the modern garden. Paddy Bowe agrees that tastes have changed and that many people find these stones 'rather hideous' to look at. But they were deliberately chosen for their interesting and strange shapes and are an important feature of our Victorian heritage. 'We may not like Victorian interiors or the elaborate carved Victorian garden furniture, but it is important to conserve all this heritage for what it is.' The delicate alpine flowers used in such a rockery also required a prohibitive amount of maintenance. The pathway through the rockery is felt to have been originally a water feature and Charles Haughey is eager to investigate if some old Victorian pipes are still in existence underneath. With the addition of a high rustic archway, this Abbeville rockery is perhaps one of the very few surviving examples, since a similar rockery in the Bewley family home has disappeared. 'To replant it and bring it back to the way it was in Victorian times would be wonderful,' says Paddy Bowe.

The general layout of the ramped pergola and *Cordonata* steps, derived

from the Italian hill villages, is banked to give the effect of a terraced garden. The pergola, which was reconstructed around the 1930s, leads from the gate and the herbaceous borders at the top to the sunken, lower circular area with its twin-tier fountain set on a classical column base. The Victorian style of planning was to allow the walker, advancing down through the gardens, time to enjoy the various displays and decorative features, instead of rushing from one place to another. As a result, the walkways at Abbeville divide at the lower fountain and deviate through separate areas of the gardens. 'The cast concrete edgings are all done later on and very cheaply,' comments Paddy Bowe, 'at the time of the Land Acts and the Free State, when the owner would have been squeezed for income.'

When it comes to the trees at Abbeville, the mild Irish climate seems to have suited Victorian ideals and allowed many unusual varieties to be planted very successfully. Species such as the ginkgo from China, cedars from Lebanon, Lawson cypresses from North America and maples from Japan have done well here over the years. Other healthy examples in the garden here are the good-sized *Drimys latifolia*, an Irish juniper, and a line of conifers including the *Thuja*, not to mention the numerous indigenous species which have been replanted year by year around the estate by Charles Haughey.

Outside the walled gardens at Abbeville, not far from the lake, there exists another interesting feature which goes back to pre-Victorian times. A cold bath, designed for a dip on a hot summer's day but for which the Victorians would have had little use on account of their extreme prudishness, was later adapted and turned into a fernery or a rockery. These cold baths were once a common feature in such parklands and would, in some cases, have been covered over by a roof, unlike the one at Abbeville. This cold pool is located in a shady place to provide the maximum privacy from the house and the general pathways. The outdoor bath fell into disuse when new Victorian plumbing allowed people to take baths inside the house. It is interesting to think, however, of this rare, surviving example and to speculate on how women and men might have taken it in turns to use it.

There are two ice houses on the Abbeville grounds, one at the far end of the lake near a boathouse and another not far from the cold bath. These

have been covered with vegetation over the years. In the nineteenth century, the ice house would have been widely used to preserve food and to make sorbets and ice creams. Sides of meat would have been refrigerated with packs of ice which would keep for months because the ice houses were built slightly below ground level. For this reason they were also located near the lake so that the ice could be easily transported when the lake was frozen. They were designed with a shady entrance, away from the sun, and insulated against the heat by a mound of soil and a shady corridor fortified with a stout iron gate. 'This ice house is probably brick-vaulted inside and was beautifully constructed at around the same period as the house,' says Paddy Bowe.

The lake at Abbeville is a perfect example of mid- to late eighteenth century landscaping, and contains all the elements of illusion characteristic of the Georgian era. In order to give the impression that the lake continued on into the distance, it was designed to look deceptively broad with a great winding shape that appears to carry on indefinitely beyond the trees. The lake was created by artificial embankments of soil which damned up an existing stream. It is an entirely man-made feature with trees judiciously planted to give the overall effect of a natural landscape.

This enormous piece of earthwork would have been carried out with the use of horses and carts and would have involved hundreds of labourers. At that time, professional landscape architects were employed by big houses to advise on and construct artificial lakes such as that at Abbeville. The rocky waterfalls in the woods along the side of the lake provided a futher opportunity to turn a very functional element into an ornamental feature by cleverly constructing an overflow to ensure that water could escape into the stream at a lower level. Charles Haughey has made attempts to stock the lake with rainbow trout in recent years, but his efforts were defeated once by pollution, once by a flash flood and once again by lack of oxygen. On the lake glides a lone swan, his mate having died some time ago. True to the nature of the swan, he has rebuffed efforts to introduce a new companion.

During the Victorian times, all entertainment was provided on the estate and the inhabitants would travel around in small specially designed

carriages to view the different features. People took great pleasure from the gardens and spent a lot of time there. Ladies carrying parasols would work on embroidery or read by the waterfall or in the shade of the fountains. The paths were designed to allow enough room for the wide Victorian dresses.

The Abbeville estate was always well stocked with wildlife and to this day, Charles Haughey has ensured that there are plenty of pheasant and duck. On a walk around the gardens, he once came across a mother duck teaching her young to fly. 'I heard these gentle little thuds; thump, thump, thump. A duck had nested up there along the top of the wall and she was pushing the ducklings out of the nest. It seemed cruel but that was nature. I had actually seen this before on films of the Arctic, the mother pushing the ducklings out. So this was the thumping sound. Once she had them all out of the nest, down she came herself and they all waddled off to the lake.'

Bees fascinate Charles Haughey and are also an integral part of the Abbeville estate; an ongoing tradition which goes back to its origins. Mike Kelly, a son-in-law of Joe Stapleton, the retired gardener who had been working at Abbeville for years, looks after the bees which exist as much to pollinate the flowers and fruit trees as to provide a plentiful supply of honey. Abbeville has its own distinctive earthenware honey pots which Charles Haughey gives away to his friends.

At the front of the house, close to the fountain, is a sundial which was formerly situated in the vegetable patch. It was put in place by Eoghan Duignan of Irish Lights who has made sundials his life's hobby. To read the sundial with absolute accuracy it is necessary to calculate the time using a table kept inside the door of the house. 'He also designed the sundial on the south-facing gable. He put this in place and aligned it for me. Your watch takes its reading from Greenwich,' says Charles Haughey. 'This sundial gives you Abbeville time and your watch gives you Greenwich time. In summer there can be up to one hour and thirty-seven minutes difference.'

'A friend of ours had his offices in the financial centre, with all the latest computers and everything you could think of. I was desperately trying to think of something to give him for his office and eventually I came up

with the idea of giving him a sundial. The latest technology along with the oldest. It's a state of mind. It's an outlook on life.'

But the largest contribution which Charles Haughey has made to the Abbeville estate is undoubtedly in the area of trees. It is an interest he has had for a long time. The problem is that the wildlife can destroy the young saplings. Even before he became Taoiseach after Jack Lynch, newspaper reports humorously mentioned 'dissident hares' at Kinsealy. There are plenty of other marauding species about as well though, according to Charles Haughey. 'The badgers come up here at night and do a fair bit of damage. The rabbits do lots of damage too. We have rabbits, hares and hundreds of squirrels and they are an awful bloody nuisance. They strip the bark off the trees, and of course this will kill a sapling.'

At the front of Abbeville house stands a heroic statue of Cuchulainn which was carved from the trunk of an elm that once stood in the field where the horses grazed. When a particularly severe storm knocked the elm down one winter, Charles Haughey commissioned sculptor Joan Smith who transformed it into a magnificent twenty-foot tall monument.

A B B E V I L L E A L B U M I

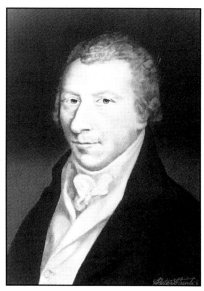

Austin Cooper lived in Abbeville from 1814 to 1830. His collection of rare books was sold in 1831 for £1968.

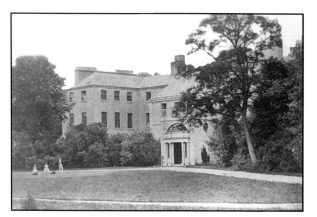

Cricket on the front oval. There was also a polo field as well as a larger cricket field opposite the gate lodge where many people in the area came to play and enjoy the game.

The dogcart which was driven with two horses in tandem.

The great cedar tree at the back of Abbeville.

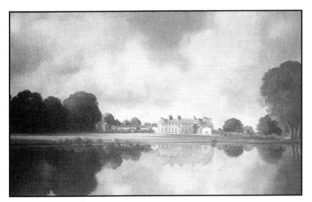

*Abbeville as it once stood with its beautiful old rose
coloured Portmarnock brick as painted by
Robert Cusack Jobson.*

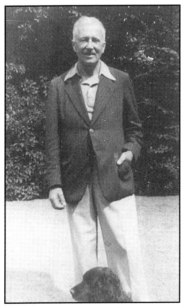

*Major Ralph Cusack, cutting a Bohemian dash (c.1935).
He spent most of his latter years travelling on the continent
with his wife Mable. 'We're off, we won't be back
until September.'*

*A peacock on the lawn during the Cusack tenure.
The wildfowl roosted in a great old cedar tree
which towered over the lawn at the back of
Abbeville.*

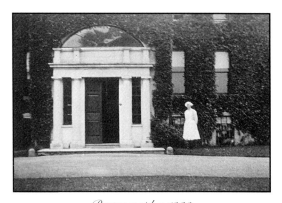

Pantry maid, c.1930.

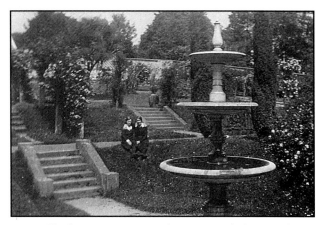

*The fountain in its original position at the bottom of
the ramped pergola in the gardens. It was later
restored and removed to the front of Abbeville where
it has assumed a central position on the front oval.*

Ann McKendry's cottage: 'It was tiny but we never felt squashed.'

Hay-making on the lawns of Abbeville.

Joan Kane's father with the box trailer for the back of the bicycle.
He would take the children off to Malahide Strand on a Sunday.

Augustus Percival Reynolds, better known as Percy Reynolds, the first chairman of CIE, bought Abbeville from Major Ralph Cusack in 1948 for a sum of £15,000. The niches in the ballroom and bedrooms which Gandon had originally filled with busts of Greek gods, and which the Cusacks had replaced with Shivas, were changed once again. Abbeville had come into the possession of a large Catholic Irish family and a new niche which was added in the principal bedroom was filled with a statue of Our Lady and given an overhead light.

Percy Reynolds belonged to the first new breed of successful Irish businessmen, and had been appointed as chairman to the board of CIE. It was said of him that he was born fifty years before his time. He had taken part in the 1916 uprising and spent time in British prisons. Deeply religious, by all accounts, he became one of the new success stories of the Irish republic. He was also a dynamic man with a great interest in horses, who bought Abbeville with the initial intention of turning it into a stud. He had bred horses in County Meath, but with his high-profile position as chairman of CIE, it made more sense to locate closer to the capital. At a distance of seven miles, Abbeville was in a perfect setting with its lands, stables and beautiful house.

Beatrice Reynolds recalls how they found Abbeville in a run-down state when they arrived first, and that the house generally required a great deal of modernisation. The Gandon interiors were in a poor decorative order and in need of restoration. The gardens had become overgrown and the estate, which had been in the hands of the Cusacks for so long, seemed to crave a new, enthusiastic owner who would restore things to their original charm. With his success in business and his considerable wealth

at the time, Percy Reynolds was in a position to engage one of Ireland's finest architects of the day, Michael Scott, to renovate the house, beautifully restoring the Gandon rooms, installing such essentials as central heating and bathrooms, as well as affecting a variety of other cosmetic changes.

In a new era of relative prosperity in Ireland, Abbeville underwent a serious face-lift. The Gandon rooms were brought back to the magnificent splendour for which they had been designed in the eighteenth century. The fine, pink Portmarnock brick facade took on a layer of pebbledash, replacing the creeper which had grown against it for years. In hindsight, this form of architectural beauty treatment seems to have been a questionable improvement which architects tend to regret, but in the 1950s, pebbledash marked the fashionable and clean new symbol of progress. Indeed, the Abbeville estate in general began to take on a more modern ranch style image with busy stables and meadows proudly populated by cantering horses.

Percy Reynolds was born in Dublin when his Irish parents returned to Ireland on holiday from America and never went back to the States. His father came from the garrison town of Nenagh where his two aunts were married to army officers and one of his uncles was in the British army. Percy and his brothers were in the Fianna with Countess Markievicz. In fact, a painting of Percy Reynolds sitting in the garden of Belcamp and painted by Countess Markievicz still exists in the family.

During the 1916 Rising, Percy Reynolds fought in the College of Surgeons while his father and his sister Molly played their part in the GPO. When the British were deporting the troublemakers, the decision was made not to send the family breadwinners so that Percy ended up being sent to jail while his father was released. Percy Reynolds' wife, Beatrice, feels that his time in England left a lasting scar on his health. 'I think he was nine months in prison in England and he had his twenty-first birthday there. He was sent first to Wormwood Scrubbs where he described seeing 'an evil look on the prisoners' faces.' Later he was sent to Stanford Prison and then on to Frongach in Wales along with other insurgents. It was an experience which Percy himself never liked to talk about.

Beatrice (Lendrum) Reynolds was born in Cork and left with her family at the age of six in 1922, to live in Sussex, returning to Dublin each summer for a holiday. It was in London that Beatrice met Percy Reynolds while he was over on business, hoping to introduce the idea of double-decker buses to Dublin city. Percy Reynolds' first wife, Eileen Stanley, died in 1937 leaving four children, among them Father Noel Reynolds who speaks with great fondness of Abbeville. Percy and Beatrice Reynolds went on to have six children.

'Percy was a marvellous letter writer,' recalls Beatrice. 'Wonderful; three times a day he'd write to me. He had a lovely sense of humour but at the same time could be very shy. He hated having his photo taken and it was agony for him making speeches at the wedding. Addressing an AGM or a shareholders' meeting was different since he'd have everything at his fingertips.'

After their marriage they lived at Fortfield Road in Terenure for three months before moving into 'Brookville', a large and charming old house on Edenmore Road in Raheny. Seven years later they found they had to leave because the corporation had decided to build a road through the grounds, going right through the recently sunk tennis court and past the hall door to join up with Tonglegee Road. Brookville was sold to the Augustinians and eventually became a school, run by the Holy Rosary nuns. There were other reasons for moving to Abbeville, however, principally that the County Meath stud farm was becoming too demanding. 'We were looking for a house in the green belt where he could keep the horses and where he would be close to work.'

At such proximity to the centre of Dublin, Abbeville seemed ideal. The estate included 120 acres of land as well as the main house, Greenwood and three lodges. 'It was mostly the land we were after. It was not for any aesthetic reasons. In fact the house didn't matter much since we knew we could always make it liveable.'

On first viewing, Beatrice Reynolds found the size of Abbeville daunting and couldn't imagine how only two people had lived in the house before them. In fact, Major Cusack and his wife would have spent a lot of their time abroad in the final years of their occupancy and when the Reynolds moved in they found only one tenth of the house had been in use. The

rest of it had all been empty. 'It was an enormous house and I found it ghastly really. When I saw it first I said, "It's awful, it's far too big," and Percy said, "Don't worry about that, we can knock it all down." But in the end it would have cost too much.'

'Michael Scott fell in love with the house when he first saw it,' recalls Father Noel. 'There was no central heating and no electricity, although we found an old-fashioned generator. He renovated the ceilings, put in new floorboards, cupboards and doors, and installed five bathrooms. In the Christmas of 1948 our family moved in to Abbeville and I remember dusting down the walls with my father on Christmas Eve.'

When Michael Scott was initially looking over the house he called the Reynolds aside and told them of an exciting discovery he had made in the older part of the house. Apparently he had found the 'Gothic room', as the family came to call it. This was the room with a low ceiling which has now become known as the Malton room. Behind the fireplace Michael Scott found a kind of store room which appeared to be hidden by partitions. When he started to pull these away, beautiful Gothic arches were revealed. Even the windows were in a Gothic shape. It was an exciting discovery and the Reynolds family liked it so much that they began to use the room as a dining-room.

It took Michael Scott over six months to complete his work in Abbeville. Architectural students came over from England to work and gain experience in the historic house. An artesian well was sunk 120 feet deep in the old coach yard causing great anxiety three days before the family were due to move in, because it had run out of water. Some of the improvements backfired later on when the house developed dry rot, and Percy Reynolds ended up taking Michael Scott to court as a result of the damage it caused.

Architect Arthur Gibney worked in Michael Scott's practice at the time and remembers the sheer panic which spread through the office when this architect was being sued. 'It was Michael Scott who put a coat of dashing on the house, which I think in a way is a pity. It countrifies the house too much, because Abbeville is a sophisticated villa rather than a countrified classical house. There was a lot of trouble during the contract. Dry rot was discovered and my boss was put in a very awkward position. It was

one of the great scandals of the fifties. I was an architectural student at the time and poor Scott had to shell out a considerable amount of money. It was the equivalent of a fortune and became a terror story in my student days, thinking of the dangers of working on old houses.'

Once the Reynolds family moved in, Beatrice remembers how Abbeville became an idyllic spot for raising her large family. With fourteen bedrooms and vast grounds, the children never wanted to go into town, recalls Beatrice. 'Their father would take a day off to bring them into Santa at Christmas time and after having lunch in Switzers' restaurant all they wanted was to go home. One of the boys got great amusement out of all the strings of sausages hanging up in the windows of the pork butchers in town.'

From Abbeville, Beatrice Reynolds began to teach her children to swim, taking them off to the sea nearby at Malahide. 'We'd watch the tides. If there was a high tide at half-nine at night I'd leave a pot of soup on the Aga and we'd go down and have a swim off the low rock at Rob's Wall in Malahide. It would be absolutely deserted. There were no houses there at the time and the reflection of the moon would be on the water. On other occasions we'd go in the car at half-seven in the morning in our togs, with the towels wrapped around us.'

The Reynolds made their own butter at Abbeville and raised chickens. The raspberry canes planted by the gardeners during the Cusack time were still bearing a great crop when the Reynolds moved in. Beatrice Reynolds recalls how she would get up at five in the morning to avoid the heat and the flies while picking them. 'I'd go out and pick about forty punnets of raspberries. At about seven o'clock I was brought out a cup of tea. I'd send out an SOS to all the family the night before – I'm picking raspberries in the morning; any offers? But you wouldn't get them up that early. Mr Hall, the wonderful grocer at the bottom of Leeson Street would take them off me, I'd get over to him before nine in the morning.'

As with most occupants of Abbeville, or anyone who had anything to do with the estate, people always found themselves becoming very attached to the place and resenting any changes that subsequent owners made. It is understandable that, in many ways, former house owners see the new

owners as invaders or even philistines. People often tend look on their former home as something sacred, long after they've moved on.

Beatrice Reynolds still feels an enormous attachment to Abbeville, even though they only lived there for around fifteen years before they put the house on the market and sold it to Franz Zielkowski. She remembers in particular the lovely fruit trees behind the vegetable garden. 'There was a beautiful Siberian crab apple tree. It was yellow and red, gorgeous in winter and made wonderful jelly. There were victoria plums and peaches too.'

Indeed, the Cusacks who lived at Abbeville before them, may have resented some of the sweeping changes brought about by the Reynolds. That is the complex nature of any old house. It will betray its former owners and devote full allegiance to the new occupant. In the end, however, it will maintain shadows and echoes of all its previous inhabitants, emerging out of the past in layers of deeply personal history. This is what makes the two-hundred-year-old estate of Abbeville so unique and fascinating today.

One of the features for which Beatrice Reynolds had little patience was the Victorian box hedges which had grown to a height of three feet. They harboured slugs, and she had one of them replaced by a lavender hedge. 'In the rockery there was a most beautiful arch and there were stones in that rockery I had never seen in my life before, they were almost like volcanic stones, ideal for planting alpine plants. The rockery was overgrown with briars, massive briars and weeds. The shrubs in the garden were lovely. We called the ginkgo tree the 'tulip tree'. I saw it flowering in Switzerland, pink like tulips, it was beautiful. There were three different varieties of magnolia.'

'In my time there were the most beautiful camellias in the walled-in pleasure garden. They flowered very well in spite of the fact that they had been raised in a glasshouse. I hope there are still a few left. The fountain which has been moved to the front of the house, I feel is quite out of place. It looks too modern,' says Beatrice, proving the point that no two owners have the same taste. Michael Scott put down a maple floor in the front hall. In order to do so, he had to tear up the large mosaic floor depicting a mastiff dog. He also removed a glass partition in the hallway

which had enhanced the vaulted ceilings but no longer seemed necessary when the central heating was installed.

There were five entrances to the house and the back door was always left open. Abbeville was perfectly situated for the sun, recalls Beatrice Reynolds. 'The west side, which was the nicer side at the back of the house, faced the sun. If it was cold at night, you'd pull across the shutters and the curtains and you'd be very warm. It wasn't a difficult house to keep clean either, maybe the fact that it was so well off the road meant there was less dust. Silver had only to be polished once a month.'

The kitchen in the basement was renovated and a huge old-fashioned table which the Reynolds bought at the time was left behind when they left Abbeville. Their nineteenth-century Regency dining-room table and a set of twelve chairs made up by Henry Hicks also remained with the house, and are still in use in the Haughey home. The only items of furniture that the Reynolds bought from the Cusacks, were two inlaid mahogany sideboards.

When the children and their friends filled up the house, Abbeville really came into its own and Beatrice recalls the Sunday nights when they had a cold supper and the 'lads would come in, five or six big long leggedy lads, and they were quite happy to have tea and bread and jam. We'd also enjoy playing a small game of cards and had friends who would come in for that.'

Abbeville was the kind of house that lent itself to weddings; two Reynolds daughters, Pat and Lorna, had their wedding breakfasts here after celebrating their marriages in Malahide. Over a hundred guests attended each of the receptions, for which the ballroom had been cleared and the doors left open allowing the guests to flow out into the garden. 'It was a great house for a family,' says Beatrice. The final Christmas before they left Abbeville was celebrated in the Gothic room where the whole extended Reynolds family including seven children under seven years of age, three of them in high chairs, sat around the dining-room table for dinner.

Father Noel Reynolds, parish priest of St Kevin's Church in Laragh, County Wicklow, now lives in a house overlooking the magnificent

Wicklow mountains. He was playing the piano at a window which looks out over this view as I arrived to see him. All around the house there is evidence of the lifelong interest in art which was handed down to him from his father.

'My father had two great interests in life; horses and art. People would come into Abbeville and go into raptures over the paintings which were hanging all around the house. They would just sit there and look at the pictures. We had two Nathaniel Hones, two by Festus Kelly, a Leech and a Jack B Yeats. There was a painting of Our Lord washing Peter's feet, and if it wasn't by Caravaggio you wouldn't have known the difference. Other Irish artists included Humbert Craig and Séan O'Sullivan.'

To one side of the fireplace in the sitting-room in Abbeville hung a painting by Festus Kelly entitled 'The Burmese Girl', depicting a young girl sitting on the ground, looking down with her hand on the floor, wearing a pink scarf with a little blue button. Father Noel also remembers the 'Gypsy Girl' on the upstairs landing, a picture he always felt was sad. 'The baby is clutched in her hands and has a shape like a cone. It had great dignity.'

He recalls how the garden was a wilderness when they first arrived. They put in some herbaceous borders and taking an idea from the film *Pride and Prejudice*, he put down a grass garden path.

The house had five members of staff at the time – the butler, the nurse and the cook, the parlour maid and the kitchen boy. Outside were another five – the foreman, two gardeners and two others looking after about fifteen horses. 'Dad was great for the horses' names. We had Sol Oriens, the rising sun, who won the Irish Derby in '41 and for which he was awarded the astronomical sum of nineteen hundred pounds. Then there were Lady's View, Dulcinia, Early Sunrise, Lady Constance, Torch, and Lenaria who won the Irish Oak. He built fifteen stables with the idea of making Abbeville pay. We sold wheat and became involved in market gardening. But things turned out unlucky for us really.'

In many ways, the memory of Abbeville remains a sad one for Father Noel Reynolds. 'I loved Abbeville,' he says, even though he feels there was a lot of 'sorrow attached to the house'.

The decline in Percy Reynolds' career began when his job in CIE came to an end. 'It was bad luck. He had been friendly with Seán Lemass and was dissappointed that Jack Lynch didn't support him but went instead for a new chairman,' explains Father Noel. He had been managing director of the Dublin United Transport Company before taking up the chairmanship of the newly established state company CIE, an amalgamation of the railways and trams. Abbeville, bought at the height of his career, was then found to be very difficult to sell and was placed on the market twice. A *Country Life* advertisement in 1958 described it as a magnificent residential stud farm on 120 acres, but it still only fetched a mere £25,000 when it was eventually sold in 1963, even though it was bought for £15,000 in 1948 and had undergone such significant restoration work in the meantime.

After leaving Abbeville, Percy Reynolds worked as consultant to various companies, among them the Great Northern Railway. 'A friend of his opened up a furniture factory called 'Nupro' with which he became involved for a short while,' recalls Father Noel. 'He went to Germany and negotiated the production of the bubble-car for Dundalk Engineering, but that didn't really go so well either.'

He then had a furniture shop on Beresford Street, oddly enough, just around the corner from Bachelor's Walk. Father Noel recalls a wooden crucifix he had in the shop, the base of which was like the Giant's Causeway with columns of rocks sticking up, and Mary Magdalen shown standing in the middle attending to Our Lord's feet. Percy Reynolds continued to work until the age of eighty-four, three years before he died.

'I went back to Abbeville once,' said Father Noel. In 1986 he met Charles Haughey in Inishboffin at the wedding of a yachtsman friend of Haughey's. 'He asked me to come and visit the house some time. His secretary phoned me and arranged a date and I went up in December of that year. He was Taoiseach then and there were Christmas cards all over the place. He told me to roam around and I felt quite nostalgic sitting there. It felt funny. The place no longer belonged to us. It was as if you wanted to get it all back to the way it was and reassemble all the furniture and pictures the way they were.'

A B B E V I L L E A L B U M I I

The staff at Abbeville in the 1930s.

*Ann McKendry (centre). 'I always hung around the house
or the yard with the men. Major Cusack asked my mother
why my sister looked so clean and I always looked so dirty.'*

*The dolls of Abbeville: Ann McKendry (left) and her sister
Maureen with their uncle, John Kane.*

The Abbeville gardeners, arch enemies of Jack Moore.
'I remember the gardener looking up suspiciously at the sound
of the pear hitting the bottom of the can.'

Lily the parlour maid with Bartle Kane and Jimmy Keeley.

Gardener Jack Curran with his wife Lily. 'He would tip his
hat to Major Cusack and give a little half-bow or genuflect
whenever he met Mrs Cusack.'

*During harvest time the cooks would send out jugs of home-made lemonade
with 'lemony coloured sugar crystals and great cans of buttermilk.
The men would love it.'*

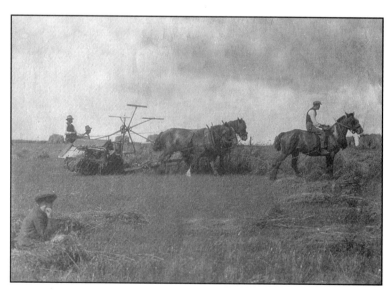

The thrashing days were cause for great excitement.

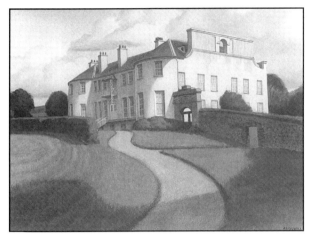

*A rear view of Abbeville as seen in a painting by Patric
Coogan, now in the possession of Richard Austin-Cooper.*

*Franz Zielkowski (right) bought the house from the
Reynolds family in 1963.*

*Abbeville and gardens falling into neglect before Haughey
bought the house in 1969.*

François Mitterand being shown the location of Inismhicileáin which he later visited,
October 1989.

Charles and Maureen with former Canadian Premier Brian Mulroney and his wife Mila
on the back steps of Abbeville.

Charles, Maureen and Eimear outside the front door with Mikhail Gorbachev's daughter Irina Vergenskaya and grandaughters Ksenia and Anastasia, August 1994.

Charles Haughey with Richard and Rosemary Austin-Cooper, descendants of former owner Austin Cooper.

ARCHITECTS ON

ABBEVILLE

With all its strange and interesting features, Abbeville house remains a puzzle for present-day architects and architectural historians. Having evolved through various phases of reconstruction like growth-rings on a great oak, it is difficult for anyone to offer a definitive history of the house. The fact that the Gandon elevations went missing and that very little documentary evidence goes back beyond this point, does not make this task any easier. Gandon audaciously redesigned an existing building, erecting rooms with tall ceilings in a house that was undoubtedly much smaller to begin with, and so created an intriguing warren of corridors and inexplicable flights of stairs. All architects can do is to respond to this tantalising challenge with an informed guess. Indeed, the more eminent Irish architects you bring to Abbeville, the more complex the picture becomes.

One of the things that experts will agree on is that this distinguished mansion was turned around. The house, which went through three distinct architectural phases, would initially have been approached from the present-day rear side, by the lake which was then merely a swamp. By taking an existing gentleman's villa and turning everything around, Gandon allowed the lake to be integrated into his general plan in which the back of the house with the generous bow-windows of the ballroom would now be facing west, the preferred aspect. The new entrance to the house would face east and the gardens to the side would face south.

Director of the Irish Architectural Archive, David Griffin, remarks that, whatever may have existed beforehand, the house appears to date back to the late seventeenth or early eighteenth century when the original structure actually faced south. 'The earliest part was a three-storey, five-

bay wing facing the walled gardens.' The evidence for this comes from the chimney stacks being positioned on an external wall. The next remodelling of the house dates to around 1740 when it took on a five-bay, two-storey entrance block, minus the porch which Gandon probably built on later.

'Its design, featuring niches at first floor level, clearly shows the influence of the German-born architect, Richard Castle (1690-5 to 1751). Castle who also designed Leinster House, was Ireland's most prolific country house architect.' This portion of the house very closely resembles Westport House, Hazelwood House in County Sligo and the Phoenix Lodge, now Áras an Úachtaráin, which were all designed in the early to mid-eighteenth century.

The Gandon phase dates to the late eighteenth and perhaps early nineteenth century when his bold remodelling extended the rear facade, 'adding a continuous Portland stone balcony at ground floor level, the splendid pedimented Ionic door cases, the steps and the shallow three-bay bows.' At a slightly later date, Gandon designed the ornamental dairy and the balancing feature at the opposite end.

Internally, Gandon is responsible for the ballroom, dining-room, the two principal first floor bedrooms and probably the single-storey entrance porch; which is remarkably similar to the entrance porch which was added to Áras an Úachtaráin by Francis Johnston. The only surviving Gandon drawings of Abbeville include the designs for the kitchen (dated 1790), a gateway, a wooden bridge and the present stable and coach house, as well as the ornamental dairy. The elevations for the house itself would have shed a lot more light on the origins of this mansion.

The imposing entrance porch at Abbeville is one the Gandon features which architects find really intriguing. Edward McParland, who compiled the illustrated study of Gandon's work, remains mystified by the Greek Doric columns on the outside of the entrance vestibule. 'It is unusual for Gandon since he's been on record as saying that he can't stand the Greek order and as far as I know he hasn't done this in any of his other work.' Abbeville's entrance columns are beautifully carved in Portland stone with very elegant flutes.

Inside the entrance vestibule, Gandon displays his mastery of architectural illusion by playing tricks with the vaulting in order to add extra height. 'You would think that the obvious thing was to have your steps on the outside,' notes Edward McParland. 'But he surprises us by having the stairs on the inside. It makes it all the more impressive and of course it allows him to have a greater height at the point of immediate entry. You can see how he is having a bit of fun with his groin vaulting.'

The vestibule is typically Gandonian and is greatly admired by architect Sam Stephenson for its cross, niches and oculi which are very similar to those of the Custom House and King's Inns. The stairs in the hallway at Abbeville are just like the parkside entrance to the King's Inns. The sandstone steps have no rail, a matter which Charles Haughey feels he needs to address. Lifting up the rug he examines a gash in the parquet floor where a tradesman once cut through the timber to install central heating, the same maple floor with which Michael Scott replaced the magnificent mosaic floor for the Reynolds family.

From the lofty hallway, hung with many impressive paintings, access leads straight ahead to the dining-room, to Charles Haughey's office on the left and to the ballroom on the right, as well as what was known as Uncle Piccolo's study. This study, like Haughey's office on the far side of the hallway, pre-dates Gandon, according to Edward McParland, because of the existence of a corner fireplace and window panels, which place it closer to the mid-eighteenth century.

Architect and curator of Abbeville, Austin Dunphy, feels that the house is a perfect example of the revolving trends in architecture through the centuries. 'You find yourself going in one direction and then you change periods and find yourself going backwards again. We see simple seventeenth century chimney pieces and then as time goes on they get more and more elaborate until suddenly they revert and start getting simple again. In the ballroom here, the chimney piece is simple. In the nineteenth century they became elaborate before returning to simplicity again in the twentieth century. In my student days, for instance, everything had to be flat, whereas young students nowadays are putting back arches and curves and vaults.'

Architect, Arthur Gibney, who designed two small villas on the estate for

Haughey's sons (Austin Dunphy designed another), feels that the ballroom is 'awfully impressive architecturally with its tremendous sense of spatial volume. The way it's compartmented into three units of space with segmental arches, boldly modelled niches and the sturdy but elegant stucco detail is typically Gandonian.'

The ballroom is a mystery, feels Austin Dunphy. Along with the dining-room next door, it is clear that its ceiling was raised to sixteen feet, even though very little is known about its pre-Gandon state. This interpretation is derived from the existence of 'a complicated stair arrangement upstairs. All the windows were raised to the elegant Gandon proportions,' remarks Austin Dunphy.

In photographs, the house always looks deceptively small from the outside. Inside, the ballroom becomes far more impressive with its bow-windows demonstrating clearly that they belong to the Gandon era. Up to then, bow-windows would have been built in semicircles, not in segments. David Griffin feels that the dining-room would have been the saloon or main living-room from the house of the 1740s to 1750s. Gandon had decided that the ballroom would be his pièce de résistance and pushed the rooms up overhead in order to give the house more impressive dimensions with his segmental arches.

The ballroom at Abbeville, unquestionably the most impressive room in the house, is furnished with period furniture and a magnificent Waterford Glass chandelier. Swiss born artist Angelica Kauffmann (1741-1807) visited Dublin and stayed for six months during which time she decorated the walls of many fine houses. In Abbeville she painted the portraits of the three Miss Beresfords from the original painting 'The Three Graces' by Sir Joshua Reynolds. Angelica Kauffmann worked in sepia and sometimes in chiaroscuro — shades of grey — which because of the shadowy effect, gave the impression of being three-dimensional.

Maurice Craig is surprised at the modest fireplace in the ballroom. 'For such an imposing room, the chimney piece is very understated.' Austin Dunphy thinks it a pity that the original black marble section of the chimneybreast has been replaced with white marble. The original chimneybreast is shown in photographs in the Georgian Society Records

of 1912. 'They probably replaced it because it was cracked. The black gave it an extra dimension, whereas the white is rather bland.'

Gandon loved to use light and shade in a room, and in the ballroom, which is divided into three parts, you can see how the niches and the arches all cast interesting shadows that add to the overall depth of the room. The walls, painted in an apple shade, look darker in the corners. 'Some walls are just purely shadow,' adds Austin Dunphy. 'Gandon loved that kind of effect. I love looking from one area to another, a kind of enfilade, as in this room where you look beyond an arch into another room.'

The motif on the very decorative, James Wyatt/Adamaesque style of neo-classical plasterwork has been copied by Charles Haughey and put in place over the entrance vestibule. 'We don't know who the plaster-worker was,' says Edward McParland, although he feels sure that Gandon designed the decorations for the ballroom himself. 'It's in the style of Michael Stapleton, who was one of the best known neo-classical plaster-workers in Ireland. But there were many other plaster-workers at the time and this is a more impersonal style. It would be easier to identify if there was something more eccentric about it.'

The double doors of the ballroom add another small puzzle to the Gandon investigations. They appear at first to have been intended as draught-proofing or sound-proofing but in fact are designed to close flush with the walls in both of these connecting rooms; something that could not have been achieved with one door because the walls were so thick. The fine 1780 mahogany panelled doors also have unusual drop handles with very elegant locks. At a later period these handles would have been finished with circular knobs.

Maurice Craig, another great admirer of Gandon's work, would like to see the ballroom change its name back to its old appellation of 'saloon'. 'The old way was to call it after the Italian from the word *salone* which means 'big room'. But if you do that all the Americans laugh because they think you're talking about a drinking shop. On the other hand, you could call it the music room.'

The dining-room, which is entered either from the hallway or from the

ballroom, is an intriguing mixture of periods. The woodwork and plasterwork in the dining-room date to the late eighteenth century, and the fireplace to 1760. Like the ballroom, the dining-room was also heightened to sixteen feet and its finely carved fireplace, apparently too good to replace, was retained by Gandon. 'It could be loosely described as rococo,' adds Austin Dunphy. 'The carved grapes tell us that it was probably a dining-room fireplace made of pine, I would think. You can see how beautiful it is with all the vine leaves.'

Due to its similarity, David Griffin feels that this chimney piece may have been carved by Richard Cranfield who was responsible for the chimney pieces in the Provost's House in Trinity College. 'It might have been painted originally and then stripped when it became fashionable at the beginning of this century to show the wood.'

The present dining-room may not have been intended as a dining-room at all, since it is very far from the kitchen and appears to be extremely impractical. The room which is now called the Malton room was used as a dining-room by the Reynolds family and has a serving hatch leading to the kitchen. It may well have been called the dining-room originally but has been given many names since. The Reynolds called it the 'Gothic room' and when the Haugheys first came to Abbeville they renamed it the 'tent room' because of its unusual interior design. Eventually they began to call it the Malton room because it houses a set of Malton prints.

There has been much debate about who might have been responsible for the fascinating rococo Gothic 'inner skin' which gives the effect of a room within a room. When Charles Haughey first bought Abbeville he invited Michael Scott up to see the house he had renovated some twenty years previously. 'He told me that this room was in the older house and Gandon liked it so much that he preserved it and built around it, as it were,' says Charles Haughey.

Edward McParland admits that the Malton room is a very foxing puzzle. 'As I go around the room and tap it, it's as if it were all a plywood front which is very beautifully draped around the room. I can give no hint when this Gothic work was done and if it was the twentieth century or work done before Gandon it wouldn't surprise me.'

'There must have been two rooms here,' he speculates. 'You wouldn't have got this all-inclusive single room separated by a free-standing hearth. You don't get that before Frank Lloyd Wright.' On the other hand, Austin Dunphy feels that Gandon may have put in this Gothic interior himself, since it would have been very unusual to find this Strawberry Hill Gothic in Ireland if it is pre-Gandon. To Sam Stephenson who was responsible for the colour scheme of dark and light mushroom with mouldings picked out in off-white, the room has an ecclesiastical feel about it. 'The interior of the room was not in character with the room itself,' he explains. 'If the window reveres are pulled back, you will see how the sides are adapted to proportion the room. The room is in disorder but is made to look orderly and planned.'

At the back of the Malton room there is a staircase which seems at first to be out of place. Like Abbeville, the neighbouring Gandon house of Emsworth also has this unusual architectual quirk of a staircase visible through a window. 'It shocked some people,' says Maurice Craig, 'but it never shocked me. They did it all the time, and with landings too. Why not? It's as though there was something improper about a staircase.'

In the hallway, close to the stairs, Charles Haughey points out a photograph of Abbeville at the turn of the century, when an enormous cedar tree was still standing outside the back door. This was the tree that fell in the great storm of 1903 and was turned into a handrail for the staircase, though later removed again. The main staircase, however, is surprisingly small for such a big house. David Griffin feels that this is quite appropriate though, since all the grand rooms in this house are on the ground floor and there was no need for a staircase leading up to a first floor drawing-room as in a Dublin house. He feels this is a very old staircase dating from the 1730s, which had been somewhat re-jigged over the years.

The elegant Gandon stables, which are still in full use by the Haughey family, turn what is essentially a farmyard building into an architectural statement. 'The simple motif of the arch, the panels and the notched cornice are very adroitly used', says Maurice Craig who remains uncomfortable, however, with the slightly overbearing symmetry of four doors on the neighbouring coach house. 'It is odd. You tend to expect a

central arch since uneven numbers are repugnant to the classical ideal. With duality you don't know where to look, you want a focus.'

The stables are built on a domestic scale and it almost looks as though the doorways would be too small to lead in a horse, which adds to the charm of their design. The building was also used as sleeping quarters for the groomsmen. The beauty of these buildings lies in their simplicity or the 'cult of the primitive' which Gandon developed towards the end of his life. 'He did the big orchestration, like the Four Courts with its great big Corinthian porticoes, and then he decided to play with something much more simple,' says Maurice Craig.

Over the coach house there is a old clock which was installed by Charles Haughey, but which looks as though it has been in place for the last two hundred years. These old stables, which house many fine horses, have changed very little inside or outside since they were built. The original plasterwork is still in place, even though it may look a bit shabby to the keen eye of Maurice Craig. 'But I'd much rather it was left like this than the wrong sort of job was done on it. I rather like lime plaster that's half falling off the wall.'

The dairy is perhaps one of the most exquisite of Gandon's designs and is admired by architects for its simplicity and unique charm. Situated on the north wall of the house and built at a later date than the house itself, it is fronted by a very distinctive Gandon arch, repeated on the other side of the house for balance. The dairy is arched all round, originally with wedgewood blue plaster, and the Portland stone floor is inlaid with black slate. The lovely stained-glass windows in the dairy have led to local people calling it 'the chapel'. This may have something to do with the fact that Mass was said in the dairy on occasion, says Charles Haughey who now has plans to restore this building under the direction of Austin Dunphy.

The dairy windows cause lively discussion among architects, some of whom feel that stained glass would be out of character with Gandon. Austin Dunphy, for instance, thinks that the windows are not in keeping with the rest of the dairy and should be removed for the sake of integrity. While agreeing that the stained glass is probably not Gandon's work, Maurice Craig feels it would be a pity to destroy something that has

become part of the layered history of the building. 'That's where our philosophies on restoration differ,' he comments. David Griffin, on the other hand, feels that the stained glass could well have been used by Gandon to cover up the farmyard behind the window. 'The frames look like 1780s,' he points out.

The two principal bedrooms overlooking the lovely wooded parkland and the lake at the back of the house proclaim all the elegant virtues of Gandon's work. The idea of placing these bedrooms over the ballroom and dining-room eliminates any doubt that they belong to the Gandon period. The windows in the bedroom over the ballroom are bowed and there is a very good quality, two-coloured, marble fireplace dating from the 1780s. The grate could have been a reproduction, according to David Griffin. The ceiling height here is ten feet, and the walls are tastefully decorated in lilac with a pale pink cove ceiling and plasterwork picked out in a deeper pink.

The neighbouring bedroom is painted in warm tones with the coved ceiling continuing all the way around to make it more attractive. The bed in this room is situated in a recess which has the elegant shape of a basilica. The pilaster over the bed as well as the fireplace are both typical 1780s, according to David Griffin, and the grate is a stunning sienna and white marble with carved wood.

The spacious bathroom, which is connected to both bedrooms, has a similar cove ceiling and was most probably designed by Gandon, though it is likely to have been a bedroom originally. David Griffin points out where there may have been a fireplace. Michael Scott was responsible for the fine mahogany wardrobes which hold Charles Haughey's favourite Saint Patrick's blue shirts and racks of ties. Sam Stephenson remodelled the bathroom, bringing this fine eighteenth-century room up to the most modern standards of comfort and utility, while preserving its overall character.

Here there are books at hand and paintings on the walls. Right in the centre of the room sits a large, cream, Italian travertine marble bath where the bather can conduct imaginary orchestras with the bathbrush or play with rubber ducks while gazing straight out on the front lawns of Abbeville with its trees and grazing horses.

THE GALLERY

In the gallery on the spacious upper landing of Abbeville hangs a wonderful and enviably simple painting of a fighting cock. Striking a bellicose stance with his hackles and tail-feathers up and a raised claw ready to defend his midden, this proud rooster is painted in vivid and perhaps slightly shocking colours by the masterful brushstrokes of the Belfast artist Basil Blackshaw. Whatever else this brilliant painting may suggest, either by design or by accident, about the divided nature of the recent past in Northern Ireland, it stands out majestically here among some half dozen sensuous nudes painted by Arthur Gibney and John Ryan, as though it were unofficially proclaiming the Haughey coat of arms, *Marte Nostro*, with its dashing and defiant pose. The lord of the farmyard commands a central place in the Haughey collection.

Indeed, every available inch of wall space at Abbeville seems to have been tastefully devoted to art, to Charles Haughey's own background in Irish political life or simply to more private pursuits such as his lifelong involvement with horses. Another Basil Blackshaw painting of Haughey's 1995 Grand National winner, Flashing Steel, leans against the sideboard in the dining-room downstairs, waiting to find a place somewhere in the gallery. It is a further sign of how the whole house seems to combine the warmth of a family home with the effects of a fine museum, in which the charming furniture and a collection of paintings, prints and sculptures reflect Charles Haughey's long political career as much as his great personal interest in art. The tables are stacked with art books and his collection often marks his own place in Irish political history, coming to a focal point in the dining-room with the great portrait of his father-in-law, Seán Lemass. This is Charles Haughey's favourite painting in the

house, the one beside which he likes to be photographed; he feels it embodies the spirit of the new Ireland.

As you arrive in the house of Abbeville you are met in the grand entrance hallway by the twin oil paintings by local artist Eithne McNally of Charles and Maureen Haughey, one on either side of the door into the dining-room. Charles is in a relaxed pose leaning on the desk of his study, one hand in his pocket with his books in the background while Maureen is seated in a more regal pose, wearing a stunning off-the-shoulder shell-pink ballgown with a fine lace shawl thrown over one shoulder, an elegant white marble statue on a pedestal in the background.

It seems entirely right that you are greeted here in the majestic entrance hallway by these gilt-framed paintings of the owners and hosts of the house in the days when Charles Haughey was a young cabinet member of the Seán Lemass administration. Charles is bearing that legendary, semi-serious, inquisitive look in his eyes; a look that enticed a number of women to pledge £3200 at a charity auction in the spring of 1996 for the privilege of having lunch with the former Taoiseach.

Every item in the house has its own little idiosyncratic anecdote to tell. The twin semicircular, regency walnut side tables underneath the portraits of Charles and Maureen were bought some twenty years ago when there was little interest in such antiques here in Ireland. 'The skilled cabinet-maker, Harold Webster, who had made them couldn't get anyone to take them,' says Charles Haughey. 'He put them into the boot of his car and brought them out to me and said I should give him what I liked for them. It's all changed now though. In those days it wasn't a profitable profession.' The two Regency sideboards in the dining-room, on the other hand, came with the original (1790s) house, and Charles Haughey employed Harold Webster who had worked for Hicks, the well-known furniture manufacturers, to make up a replica for him. On the sideboard are a number of coasters which Haughey had made from yew and walnut trees fallen on his lands.

On another wall in the hallway hangs a painting by Robertson Craig of the Haughey family in the grounds of Grangemore before they moved to Abbeville. Prophetically perhaps, Eimear Haughey is seen in this painting sitting on a horse with her youngest brother Seán; she went on to become

a prominent showjumping rider, winning the European junior championship on her father's horse Feiltrim at the age of seventeen. Outside the stable area there is a fine, bronze head of Feiltrim by Gary Trimble. The other two Haughey boys are in the hallway painting, one on a tricycle and the other holding one of his mother's Irish wolfhounds.

Along the hallway wall you also come across the fascinating, turn-of-the-century photographs of Abbeville when the great cedar tree was still standing and when uncle Piccolo's horses were waiting in tandem outside the hall door. Journalist Bruce Arnold recalls a visit to Abbeville in the sixties with his wife Mavis, whose aunt married into the Cusack family. He brought Roy Cusack and his wife Maude with him. 'Roy found these photographs of Abbeville and since he had no need of them, he said he would be glad to give them to the Haugheys. 'We had a very nice visit,' recalls Bruce Arnold. 'We met Mrs Haughey and looked around the house. Roy was able to describe the house as it was before.'

Portraits of the first Cusack owners of Abbeville hang on the walls of Bruce Arnold's drawing-room in Glenageary. James William Cusack was then the surgeon in ordinary to Queen Victoria, and his wife Elizabeth Frances Cusack was a noted beauty in 1821 when the paintings were created by Martin Creegan. Another of Bruce Arnold's prized possessions is a large painting by Eddie Maguire of Charles Haughey wearing a riding hat. A smaller version of the same portrait of Haughey in profile hangs in the entrance way leading to the ballroom at Abbeville. A feature of Eddie Maguire's work is that he didn't paint his subjects as they were or as they might want to be seen, but rather as he imagined them himself.

An even more dramatic Eddie Maguire portrait of Haughey's former arts adviser, the poet and biographer Anthony Cronin, leaning forward rather mischievously with a book in his hand, can be seen in the dining-room. This is a painting that subtly records Haughey's lasting involvement with Irish culture when he became a true patron of the arts as former Minister for Finance, boldly establishing the very unique principle of Ireland as a tax-free sanctuary for writers and artists in the 1969 Finance Act. To this day, he is perceived by many to have achieved more than anyone else in the government of his time to encourage artistic creativity in Ireland, setting up a protective shield for artists and creating a climate where the arts

could flourish. Though he did little for the Irish Film Board, he was responsible for the setting up of Aosdána, a foundation for writers and artists, and the inauguration of the Irish Museum for Modern Art (IMMA) at the Royal Hospital in Kilmainham, which has become one of the focal points of Irish contemporary art.

While subsequent Finance ministers are remembered more for the banality of taxing pints and cigarettes, Haughey has linked himself to Irish culture, and stands out as having forged an imaginative vision for the arts in Ireland. Indeed, he has also been closely involved with the setting up of the Tyrone Guthrie centre for artists at Annamakerrig. A portrait of Haughey which dates back to the time of his support of the arts in Ireland, hangs in the dining-room of Abbeville. In fact, there are quite a few portraits and busts of Charles Haughey exhibited in Abbeville, most presented to him, some commissioned and others purchased after the artist decided to use Haughey as a subject. Such is the case with the portrait of Haughey by Rossa Nolan, who painted him from a photograph.

The dining-room also houses the painting by Eileen Mulvan of Peig Sayers, the legendary writer from the Blasket Islands with whom Charles Haughey feels a great affinity ever since Inismhicileáin, one of the smaller Blasket islands, became his exclusive holiday retreat. But he also describes her as an 'auld villain who broke many a schoolchild's heart' when it came to homework.

In the hallway hangs a large oil painting by Patrick Hennessy depicting a white horse galloping across a summer meadow, its mane flying behind in the wind. The striking thing about the painting is that even though this rather mythical, Celtic landscape is rendered in broad daylight, the artist has added a half-moon in the corner of the picture. It is the kind of quirkiness that appeals to Charles Haughey, and came about as a result of the first moon landing occurring on the day that the artist was finishing the painting.

Haughey says he likes to be able to identify with works of art and is drawn to paintings where the person or the places are familiar to him. One of the finest paintings in his gallery at Abbeville shows Portmarnock Strand where Charles Haughey once played as a child and where he now

goes riding every morning. This was painted by Nathaniel Hone who lived in the nearby St Doulagh's Park at the turn of the century.

In Haughey's study hangs a photograph of his daughter Eimear in evening dress, taken on her twenty-first birthday. Over the mantlepiece is a dramatic painting of Inismhicileáin with eagles, by Richard Ward. The cork walls of the neighbouring bathroom also provide space for prints of Irish landscapes as well as sketches or preliminary studies by the sculptor Edward Delaney. This bathroom was designed by Sam Stephenson with a Japanese atmosphere and some Japanese prints. 'The cork tiles, which are really meant to be on the floor, have a sound-proofing effect as well as giving off a nice oaky smell,' says Sam Stephenson who has incorporated sinks of grey Wicklow granite and a twelve-foot long curved granite counter-top on which stands a row of beautiful leather-bound books and a solitary bottle of Eau Sauvage.

The Malton room at Abbeville is devoted entirely to a collection of medieval prints of Dublin city which Haughey acquired along with the house. These were all drawn in the eighteenth century before the Act of Union, around the time of Beresford, which makes Abbeville a good home for this set. Art expert Ciara Ferguson feels that the 'prints themselves are not particularly noteworthy and are reproduced in huge quantities, but the fact that this is a complete collection of all twenty-eight prints, plus Ordnance Survey maps, is unusual. The only other complete collection hangs in the Dáil.'

On a tour of Abbeville, Ciara Ferguson described the art collection as fragmented but significant in the sense that it demonstrates the owner's great interest in art. 'Charles Haughey isn't exactly an art collector, yet he has an unusual and very contemporary Irish art collection that hangs erratically on all available wall space in his home. The paintings were acquired in the same way as one might acquire crystal, antiques or books. Indeed his collection of books, including many art books, is more reflective of his personality simply because they have been chosen by himself. Haughey's art collection, on the other hand, has been formed from presentations, gifts or commissions. Despite the fragmented nature of the collection, too diverse to be representative of one man's taste, it is still an integral part of his environs, his home.'

Walking around the Malton room, Charles Haughey points to scenes such as the Four Courts or the Custom House with ships docked alongside and wood being floated up the river. 'On one of the prints you can see how the pigs were rubbed out by Malton using one of his fingers,' remarks Haughey. 'But the man who was herding the pigs is still visible with his staff. They obviously didn't like the idea of pigs wandering around in the foreground of the parliament, not unlike what a Dáil committee today might do. You can see that the pictures were drawn before the Act of Union, since there is no crown on the Dublin coat of arms.'

Beyond the Malton room, which also contains a wall of Waterford Crystal glass, many of the items having been presented to Haughey as gifts from world leaders, you pass through a corridor which is lined from ceiling to floor with photographs of the family in its great moments such as the weddings, political triumphs, races and at their holiday island of Inismhicileáin. Among these framed photographs Haughey can be seen in the company of many of the prominent world leaders of his time, such as Robert Kennedy, Ted Kennedy, François Mitterand, Helmut Schmidt, Bob Hawke, Brian Mulroney and Margaret Thatcher. This corridor leads on to the bar with its own store of paintings and artefacts and a room at the end which serves as a comfortable family sitting-room with a large TV set.

In the extensive basement in which the billiard room runs from the front of the house right through to the back, there are many more paintings, photographs and artefacts. Charles Haughey points to an aerial photograph of Inismhicileáin and talks about ancient Celtic and monastic sites on the island. 'That old Celtic feature is called a *leacht* or stone. It was always placed in front of a monk's cell and archaeologists still don't know what its purpose was. There is an altar table inside and those walls were all part of the monastic layout, the sacred ground going back to very early Christian times in the seventh or eighth century.'

Among dozens of racing trophies are medals from Charles Haughey's schooldays at St Joseph's in Fairview. 'There's the Powers Gold Cup that we won at Fairyhouse, and some of those other trophies are for greyhounds. You can see all the medals I was awarded when I was playing hurling and football in school. That's what you played in those days. But I didn't go on, because when I went into the FCA it took up all my spare

time so that I couldn't keep on playing. But my younger brother Pádraig went on to win an all-Ireland football final medal.'

Here also are the words spoken by Charles Haughey on the day of his retirement from the Dáil on 12 February 1992, when he declared that if there was an accolade by which he would like to be remembered, it was for his attempt to serve the people of Ireland. The words 'He served the people, all of the people, to the best of his ability' spoken by himself in the Dáil on that day are mounted on a sculpture in the shape of a book presented to him by Paul Ryan. There is an atmospheric photograph here too of Charles Haughey after his boating accident in 1986 when Celtic Mist crashed off Mizen Head. In the photograph, himself, his son Conor and some relieved companions appear very jolly after their narrow escape, recovering with a few glasses of rum in Bushe's pub in Baltimore, County Cork.

In this back hall in the basement with its many shelves and display areas, there is a wooden carving of Fionn MacCumhaill by the Wexford artist Lorna Skrine. 'I had a Cuchulainn on guard in front so I decided to have a Fionn MacCumhaill at the back for all-round defence. I gave her some yew wood which we had and she carved that beautiful piece out of it.'

Along the upper landing which looks out over the entrance vestibule of Abbeville and existed before the remodelling by Gandon, the hallway and two flanking rooms serve as the main gallery, lined with varied and interesting works of art. Along with the beautiful, black, Kilkenny marble fireplaces dating back to the 1730s, these rooms which once served as the animal museum and the British army uniform museum with medals of the Order of the Empire painted on the ceiling, now house such works of art as a Robert Ballagh impression of a Fianna Fáil Árd Fheis. Haughey is also rendered in a portrait on the wall here by Louis Le Broquey in his distinctive and ghostly style.

There are paintings here too of Haughey's beloved Inismhicileáin, next to a large and elaborate photo-realist self portrait with camel by the artist Paul Funge. Charles Haughey cannot pass this painting by without telling the story of how his daughter Eimear once recognised Paul Funge at a function and said: 'You're the man on the camel!' A series of paintings of the stations of the cross by Patrick Collins, whom Haughey thinks of as

one of the greatest Irish artists, ·have not found a space here and are stored upstairs because Haughey feels that 'Abbeville is not the place for the stations of the cross.'

There are further paintings by contemporary Irish artists and on the table in the landing there is a virtual stampede of blue porcelain horses which Charles Haughey has put together as a collection over the years. Each time he went to Paris on official visits he picked up another few of these horses, of which there are now approximately a hundred.

Apart from the unforgettable fighting cock, however, the most striking work of art is seen out through the window of the landing hall on the lawns of Abbeville: a statue of Cuchulainn. Charles Haughey likes to survey the grounds from the window and admire the cascading water in the fountain with the sun shining through making it look 'like diamonds'. The sculpture of Cuchulainn, the great warrior of the Ulster cycle, is a dramatic statement of continuity in Irish history.

Art expert Ciara Ferguson feels that this is one of the most imposing pieces at Abbeville. Because of the limitations of the wood, which was carved while it was 'green', nature went on to contribute to the piece with a great crack which the artist, Joan Smith cleverly incorporated into the design. Ciara Ferguson explains that while the artist was working on the wood at a studio in Cheekpoint, County Wexford, she managed to open up the tension in the grain structure of the wood by allowing a big crack to develop down the side of Cuchulainn's face, a feature the artist describes as 'an old battle scar.'

This work of art, which took months to complete with the use of traditional hammer and chisel, was described by the artist to Ciara Ferguson as 'synthesising man and elm tree into a symbol of strength and stability, a link between the past and the future.' Standing where it is, on the lawns of Abbeville, along the approaching avenue, this twenty-foot tall sculpture, with its round shield and sword and its symbolism of heroic bravery in the face of the enemy, adds a mythical dimension to the home of former Taoiseach Charles Haughey.

THE HAUGHEY

HOUSEHOLD

Though Abbeville leaves you with the unmistakable impression of a formidable, stately mansion with its twelve bedrooms, four reception rooms, galleries, basement and kitchens, it also manages at all times to disguise itself as a cosy family home. To a great extent, this is due to Maureen Haughey who has always resisted the Victorian model of being served upon by countless staff and maintained the more homely balance of an Irish household. Abbeville would undoubtedly become impossible to keep without some domestic help, but the heart of this family residence centres very much around Maureen, the mother of four children, who has always insisted on taking an active part in the running of the home.

Now that Charles and Maureen are the only occupants left at Abbeville, some of the bedrooms are unused and at times the house may appear to shrink down to the kitchen or the TV room or to Charles Haughey's office. But this would give a false impression of the Haughey home, since it is now as busy as ever with a steady stream of visitors and the constant work being done around the house and farm. If anything, Abbeville is busier than ever before with lunches and dinners for friends and visiting dignitaries, not to mention the frequent visits from the Haughey children and grandchildren.

'It's a lovely house,' says Maureen Haughey, who couldn't imagine herself living in the city. 'I grew up in a large, old house in Palmerston Road in Rathmines with plenty of room and places to put things. You like to spread yourself around. Abbeville has great character and there is great peace here. Also you are near everything, near the airport and Dublin. I'm always saying 'I think I'd rather live in a smaller house.' But then we're

planting all the trees. It would be so hard to leave. I can't see myself ever being comfortable in a town house.'

With one indoor housekeeper, Patricia McNamee, and a daily help, Maureen Haughey finds the challenge of maintaining Abbeville just about manageable. 'It is a difficult house to keep,' she says. 'The kitchen is downstairs and the dining-room is upstairs and it does entail a lot of running up and down.'

The kitchen in the basement was renovated with maximum efficiency in mind by the Reynolds family some twenty years before the Haugheys moved in. The Haugheys added on a large scullery where all the cooking is now done. In many ways, this bright and comfortable kitchen space makes it the focal part of the family home. Here you will see the morning paper open across the table with a mug of tea beside it. In the case of Charles Haughey, this is most likely to be herbal tea.

'The kitchen is quite convenient. Two secretaries who are working here and the family will have their lunch at the house. It's only when you have visitors that everything has to be carted up and down.'

Whenever large receptions take place at Abbeville, the kitchen is invaded by catering staff and comes into its own with all its cupboards and working areas. The ancient dumb waiter was once operated manually and is said by Maureen Haughey to have provided endless entertainment for the children, who used to wind one another up and down inside it before it was motorised. She describes it as being 'a little antiquated but it can be handy.' The dumb waiter dates back to the early part of this century and was designed in such a way that food and laundry could be conveyed all the way to the top of the house.

'Abbeville was a wonderful place for the children to grow up,' says Maureen Haughey. The swimming pool, designed by Sam Stephenson with a Liscannor stone poolside surround, was installed before they moved in. 'Ciarán and Seán were very young and they couldn't swim when we came, but within a matter of months they were like water babies. They had tree houses in the garden. When they got older, they took over the lodges which gave them great freedom. You just let them off.'

When the Haugheys first moved into Abbeville people remarked how good it was to have a family living there again. Even though the mansion has the thriving atmosphere of a 'lived in' home, it is also a very restful house, feels Maureen Haughey. She is drawn to the great sense of history which clings to the large elegant rooms of Abbeville. 'I wonder a great deal about the people who lived here. Unlike some other houses, you never get the feeling that there are ghosts in this house. I think that the people who lived here must have been very happy.'

Abbeville and its estate was always populated by lots of animals. Maureen Haughey has always had a great affection for dogs and speaks about the family Jack Russell, 'Nipper', as though he were a powerful persona in his own right. He has met most of the great foreign statesmen and women; every visiting dignitary. As Seán Haughey confirms, 'No matter who was there, Cardinal O'Fiaich or the cabinet, Nipper would arrive in and plonk himself on the rug. He knew exactly what was going on and how the country was being run at the time.'

Maureen Haughey, who has always taken a great interest in breeding wolfhounds, greyhounds and more recently, labradors, finds that Nipper remains the most demanding of all. 'The vet always laughs at me. He says that with all the animals we have, large and small, the biggest bills are always for Nipper. He's the boss when it comes to the other dogs, and sometimes when a bitch is in heat he'll take on another dog, and most of the times he's been with the vet is because he has been beaten up.'

The interest in Irish wolfhounds began when the family still lived in Grangemore, Raheny. Ever since then Maureen Haughey has been involved the Irish Wolfhound Society and has sent a lot of wolfhounds off to America. 'I gave it up for a while, but in the last couple of years I am kind of getting back into it again. I have a dog, Pete, and two bitches, Inis and Sweeney. Growing up I always thought I'd like an Irish wolfhound, especially with their strong Irish history. They are very gentle dogs and they suit the house. Charlie gives out about them barking at people, but maybe it's a good thing that they do.'

Maureen Haughey, who was secretary to the Fingal Harriers for many years, also has an immense fondness for horses and did a great deal of

riding in her time. Two of her friends kept their horses at Abbeville and with another friend next door, the four companions would go off on the hunt together. She describes it as a great day out which she hugely enjoyed until her horse seemed to be getting old. 'Then I thought I was getting too old as well and I said to myself I wouldn't get a new horse at a certain stage.' Once a week, disabled children are invited to Abbeville to take part in a ride. 'In fine weather we bring them up for a ride through the woods,' says Maureen Haughey.

Charles and Maureen Haughey procured two donkeys from a refuge in Cork, which have been named Finn and Ferdia, and are kept on the estate for the grandchildren. Seán Haughey, TD who married Orla O'Brien, daughter of the local doctor in 1991, have two children, Seán Patrick and Ciara. Ciarán Haughey and his wife Laura have one child, Caoimhe.

In a further gesture, each of the Haughey children, Eimear, Conor, Ciarán and Seán, were given fairly good sites of land on the Abbeville estate. 'Each of the children got the gift of a site and, of course, it was an economical option to stay here,' reveals Seán Haughey. 'We are a very close family as well and we like to see a lot of one another. We call in and out of Abeville all the time.'

Eimear Haughey is married to horse trainer John Mulhern and lives in Kildare. She admits that she feels a bit left out of the action, but she calls in to Abbeville a great deal too and has plans to build her own house in the grounds of Abbeville 'one day when I'm old and have retired' says Eimear, who will never forget her first impressions of Abbeville.

'I was fifteen at the time and I thought I had never seen a house as big in my life before. We had often driven by on our way to Malahide but I had never realised there was even a house here. A German friend of mine was helping with the translations for the negotiations on the house with the former owner who was a German. I didn't know when I went up with her to the house that my father was planning to buy it, and I was amazed when I found out.'

'Conor and I used to pal around and ride a great deal. When Tommy Brennan leased the yard the place became a real showcase for showjumpers with people from all over the world coming to buy horses. One of them,

Ambassador, was bought by Gratiano Mancinelli and later went on to win a gold medal at the Munich Olympics.'

'My memories of the house are very happy. There was always action, we would be hunting, or off exploring and we always had friends staying, sometimes up to four or five. The house always seemed to be full with people gathering for various reasons. So much has gone on there, the political dramas and spontaneous parties. If there was something to celebrate there was never a question of going anywhere else. It was always Abbeville and still is. As I drove up the other day a squirrel ran by me, then a pheasant jumped out, then a rabbit, and along with all the trees and horses and cattle it really is a magnificent place.'

Maureen Haughey remembers the occasion when Pavarotti came to Abbeville to buy a horse. 'A friend of ours who was working on the committee of the opera house heard that he wanted a horse and brought him out here. Theresa in the yard was working with a young horse named Herbie which really appealed to Pavarotti since his manager also went by the name of Herbie. So he bought the horse and off it went to Italy. Pavarotti was very nice, very easy-going. And the last time he sang in the RDS, Eimear and I went in to meet him and we've kept in touch ever since.' On another occasion Lord Snowdon came up to Abbeville to have his photograph taken for a magazine. He was looking for a black labrador for the photograph, and Maureen Haughey went out in the yard and found nobody anywhere in sight. It turned out that one of the horses had bolted and was down in Malahide kicking all the cars.

Just a field and a hill away from Abbeville house, Seán and Orla live in a picturesque Tudor house which was designed by Arthur Gibney and based on the red-bricked gardener's lodge situated inside Dublin's most famous city-centre park, St Stephen's Green. The 2000 square foot, two-storey home features balconies off three of the four bedrooms, and includes a large open-plan living-room and spacious terrace. 'We decided to call it 'Chapelfield Lodge' because we knew this field as the chapel field when we grew up. Also it is in view of Kinsealy Chapel. We were going to call it after the townland, which is known as Ballymacarty but we went against that because we thought it sounded a bit like a bottle of beer.' The remains of an old mill wheel on a river at the back of the house will soon come in for restoration, promises Seán Haughey.

His two brothers Conor and Ciarán have also decided to live on the estate. Ciarán has begun to build a house in the same Arthur Gibney design, while Feiltrim House which was built by Conor Haughey and his wife Jackie, was designed by Austin Dunphy and is situated on Feiltrim Hill. Being so close to Abbeville allows them all to cross the fields quite frequently to visit Charles and Maureen Haughey.

For Seán Haughey, these walks back home evoke great memories of his childhood spent in Abbeville. He remembers the hiding places in the wilderness around the gardens where rabbit and pheasant lived. He recalls the wild schoolboy nights on the lake and the great slap-up dinners around the barbeque, and eating sausages in the greenhouse before chasing off again on some secret mission. 'We moved in when I was seven and it was really very exciting. At that age the house seemed absolutely huge. This man from the Netherlands came to stay for a while and he taught us how to catch eels. He had the real art. We would spend hours down there catching these six inch eels. We didn't eat them. We threw them back.'

Seán Haughey feels rather wistful that, unlike most schoolboys, he never had the chance to rob an orchard since all the Abbeville fruit was there for the picking. He remembers growing broad beans and potatoes as a teenager but 'something came out of the wall and ate them.' Abbeville grew prize conkers and Seán remembers leaving them in the airing cupboard overnight to make them harder for the conker contests in school next day. He also recalls finding a pheasant nesting among the mint, causing great speculation about the flavour of the bird, were it to be eaten.

It was Seán who discovered the ice house one day while he was messing about in the garden with his pet dog. 'The dog started to dig and scratch away at something. I went and got a shovel and after digging down a bit didn't we discover this little doorway leading somewhere. We thought we had discovered this underground tunnel that all the locals used to talk about. But it turned out to be a storage house for ice with a fifteen foot drop to the bottom. We were quite disappointed that it wasn't the secret tunnel.'

Abbeville was a fully-fledged farm which involved 'very serious work' such

as bringing in the hay, for which the Haughey children always got paid. Jimmy Saville and Lady Valerie Goulding would come to the house each year after the Jimmy Saville Charity Walk which was undertaken in the '60s and '70s by virtually every schoolchild in Dublin. 'Jimmy Saville was always the centre of attention. He was a bit batty, always cracking jokes. We were young and totally in awe of him.'

With such fond memories of the house, Seán Haughey still likes to keep an office in the basement. 'The minute you walk in, you can feel the comfortable homely atmosphere. I suppose the fact that we all live around the place has something to do with that. My mother and father have a lot to do with the atmosphere since they are very hospitable and charming host and hostess. A lot of people say that the house is not a showpiece at all but a family home.'

Following in his father's footsteps, Seán Haughey now has the modest beginnings of his own picture gallery in the downstairs cloakroom at Chapelfield Lodge. On the wall are cartoons of Margaret Thatcher, Helmut Kohl and François Mitterand, as well as a cartoon of the comedian Brendan Grace cautioning the newly-appointed Alderman Seán Haughey not to 'let the power go to your head' on his way to the Mansion House. There is a photograph of Seán Haughey with Gay Byrne and another with Nelson Mandela as he received the freedom of Dublin city. 'Here are the Oscar winners of *My Left Foot*; Daniel Day Lewis and Brenda Fricker. And here is a cartoon of the new Haughey grandchild who is saying 'Mara' as opposed to Mama!'

Among the paintings at Chapelfield Lodge, there is one of the Mansion House which Seán Haughey received from his father to commemorate his term as Lord Mayor. In his study there is a cabinet made out of Abbeville walnut, a desk which was made by Des Fitzgerald of County Meath, who also made furniture for Abbeville and the new government buildings. The study has a political theme with pictures of Seán Lemass with John F Kennedy, Seán Haughey as a baby with his father and grandfather, and a photograph of Eamon de Valera with Orla's parents. Her grandfather, was John S O'Connor TD. Over the mantlepiece in the dark rose-coloured dining-room hangs a large painting of Charles Stewart Parnell; described by Seán Haughey as a 'great parliamentarian' for whom he has a great regard.

For the present, while Abbeville continues to live on as a thriving estate, the question of what will eventually become of the place seems to recede into the distance. A house of this size and historical importance will inevitably invite such speculation in the coming years, however. What about the future of Abbeville, one is compelled to ask? Will it remain in Haughey hands? Is there a possibility that the house might eventually be taken over by the state as an official Taoiseach's residence? Or will it pass to new owners who will lovingly preserve the house and estate and carry on many of its traditions into the next century?

With three of the Haughey children settled in their own homes on the estate, it seems unlikely that any of them would wish to take over a house of Abbeville's size. 'I doubt that any of us would move back in since it's a pretty expensive house to keep,' says Seán Haughey. 'It would need a very benevolent owner to keep it up. Some sort of state of local authority ownership could be considered as well. I really don't know what the future holds for Abbeville. In fact there is very little talk about it.'

Charles Haughey is in no doubt that a house as architecturally and historically significant as Abbeville will be kept on. 'You can't plan for the future really,' he feels. 'But I don't worry about it. I would be concerned alright, but I don't think there is a real problem in that more and more houses like this are being appreciated and their importance understood. I think there are a fair amount of people who would mind a house like this and look after it.'

The fact that Abbeville has been consistently restored and renovated leaves it in a very sound structural and decorative condition. Its excellent state of maintenance as well as its proximity to Dublin will ensure that it will always be a very desirable property. Charles Haughey feels that the questions of costly upkeep are ultimately very 'dreary' when speaking of a house of such character and importance, 'even though expert young farm manager Derek MacDonnell makes every effort to make the place pay.' Unlike the late sixties when Charles Haughey bought Abbeville for less than today's cost of an average suburban home, there are many more potential purchasers of means nowadays who could easily keep a property like this running.

'All over the country there are fine houses which have been bought, restored

and occupied by Irish people. At the beginning of the century old houses were allowed to fall into ruin. But the tide has turned and I don't feel pessimistic about the future of Abbeville,' says Charles Haughey.

It has to be taken into consideration too that Abbeville is situated on the fringes of an expanding city, and even though it is still zoned as agricultural land, this may ultimately change. What is so attractive, according to Charles Haughey, is the fact that people in this area of north Dublin and so close to the city are still involved in farming. 'You see the sturdy survival of a rural community here. It's a very enjoyable area in which to live with the convenience of being seven miles from the centre of Dublin in comparative peace and quiet.'

Charles Haughey has never really considered himself as being in retirement. Instead, he regards his present-day life at Abbeville as a new phase which has allowed him to concentrate on many interests and hobbies including the outdoor activities which the estate offers such as riding, planting trees and farming red deer.

Unlike the Cusack family who lived in Abbeville for over one hundred years, Charles Haughey has no similar ambitions for his own family. He feels it is very much up to themselves what they will do in the future. 'I don't have any pretensions. The children can do what they like. Whatever suits them. They will make their own decisions.'

Charles Haughey is described by his son Seán as a doting grandfather who is very fond of taking the grandchildren by the hand for a walk around the estate. He is not the stern disciplinarian that people might imagine him to be and he seems to have a lot of time now which might have been devoted more readily to his career in the Dáil when his own children were small. The robust and often impenetrable image of Charles Haughey as Taoiseach can be seen to soften here at his family home in Abbeville. Seeing him in the company of his grandchildren, there is no doubt that Charles Haughey's magnetism still continues to work on younger generations. While we were in the kitchen at one point discussing the great Gandon heritage of Abbeville, Ciarán's two-year-old daughter Caoimhe came in and flung herself at Haughey, announcing his name with a trill of childish excitement. 'Charlie', she exclaimed, throwing her arms around him, waiting for him to take her for a walk around the grounds.

Glossary

basilica	originally a Roman hall of justice, its rectangular plan shape consisting of nave, aisles and apse, was later used in church design
bow-window	a projecting window with a segmental or semicircular shape
Corinthian	the third and most ornate order of Greek architecture, characterised by carved leaves at the tops of the columns
Doric	the first and simplest order of Greek architecture, characterised by sturdy, baseless, fluted columns
drum and dome	a semi-spherical roof, and the raised cylinder on which this dome sits
flutes/fluting	the vertical grooves on the shaft of a column
groin vaulting	an arched ceiling in which the arches, or vaults, intersect at right angles
Ionic	the second order of Greek architecture, characterised by a slimmer column with a simple base and distinctive 'scrolls' at the top
niches	shallow recesses in walls, often arched, usually to contain statues
oculi	a circular or elliptical opening in a wall, sometimes blank
pilaster	a rectangular column projecting from a wall
pediment	the triangular front of a building in Grecian style, usually over a columned portico
roundel	a circular mould or panel, in this case a mural
Strawberry Hill Gothic	a revival of the medieval Gothic style, applied to domestic architecture in the late 1700s
stucco	plasterwork used either to coat external walls or for interior moulding and ornamentation